759.2 BUK

WITHDRAWN

John Moores Painting Prize 2014

ual: university
of the arts
london
wimbledon

library : merton hall road
london SW19 3QA

020 7514 9690
www.arts.ac.uk/library

Walker
Art Gallery

In partnership with
**JOHN MOORES
LIVERPOOL
EXHIBITION TRUST**

D1142487

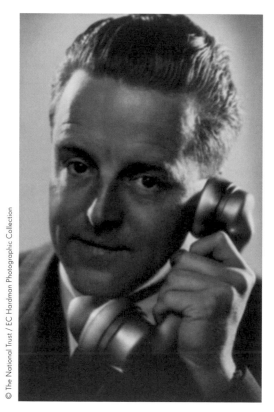

© The National Trust / EC Hardman Photographic Collection

John Moores, 1933. Photograph in the collection of the Walker Art Gallery.

In 1957 John Moores (1896-1993) sponsored a competition for contemporary artists at Liverpool's Walker Art Gallery, with the intention of showcasing the best of new British painting.

The exhibition's main aims, stated in the first catalogue, were:

'To give Merseyside the chance to see an exhibition of painting and sculpture embracing the best and most vital work being done today throughout the country' and 'to encourage contemporary artists, particularly the young and progressive.'

The John Moores Painting Prize has since been held almost every two years. It has become one of the most familiar events in the British art world and now forms an important part of the Liverpool Biennial, the UK's Biennial of Contemporary Art.

This year brings the 28th exhibition since 1957, the *John Moores Painting Prize 2014*, and celebrates the third *John Moores Painting Prize China* in Shanghai.

Contents

Cover image: Tom Hackney, Chess Painting No. 21 (detail)

Foreword

For the Walker Art Gallery, staging the *John Moores Painting Prize* every two years is always an energising and thought-provoking time in the venue's exhibition calendar. Not only do we have the privilege of showcasing British painting, establishing new relationships between this leading UK gallery and some of today's most exciting painters, but we also have the opportunity to celebrate the continuing achievements of the many artists who have appeared in the exhibition since its launch in 1957. In the last two years alone previous prizewinners Peter Doig, Martin Greenland and Sarah Pickstone have all been the subject of significant solo shows. In 2014, Bruce McLean will have his first major retrospective exhibition, in Colchester, with his prizewinning picture *Oriental Garden, Kyoto* playing a key role in telling the story of his career. Another prizewinner, Lisa Milroy, has turned juror, making up part of the selection panel for the *John Moores Painting Prize China*.

As is often the case with contemporary art, the *John Moores Painting Prize* is a catalyst for stimulating debate and comment, and sometimes for polarising opinions. But that is just as it should be - it is an arena in which we are encouraged to reflect on the role and status of painting today. It is, of course, also a chance for artists to show their work in a major public gallery setting with all the fresh exposure this brings. In a cultural landscape where artists are continually challenged by the difficulty of securing funding to support their practice, the opportunities a show like the *John Moores* affords play an ever increasing role in helping to promote UK talent. This is something we should all seek to celebrate.

Our jury this year - art critic and Director of Artistic Programmes at the Royal Academy, Tim Marlow and artists Tom Benson, Zeng Fanzhi, Chantal Joffe and Lynette Yiadom-Boakye - rose to the exacting challenge of reviewing almost 2,600 entries with great energy and diligence. We are extremely grateful to them for their involvement and commitment to this show. We also extend our thanks to all the members of the John Moores Liverpool Exhibition Trust and their Artistic Director, Bev Bytheway, for their ongoing support. The European Regional Development Fund has also given

assistance to the project with a significant grant for a series of modern and contemporary art shows grouped under the banner of *Modern Masters*.

We are also deeply indebted to all our supporters: David M Robinson, First Prize sponsor; Investec, sponsor; Weightmans, partner; Rathbones, sponsor of the Visitors' Choice Award; Hope Street Hotel, official hotel partner. Quite simply, they have made this project possible through their great generosity and enthusiasm. It goes without saying that these are challenging financial times for museums and art galleries. Without the tremendous foresight shown by these enlightened sponsors in giving their support to this project, the 50 artists whose work you can now see would have been denied this important opportunity. We extend our utmost appreciation to them as shining examples of what can be achieved when businesses have the vision to support the work of the UK's cultural institutions, and hope that others will be inspired by their lead in the future.

The 2014 *John Moores Painting Prize China* was held for the third time in Shanghai, on this occasion at the Himalayas Art Museum, between 15 April and 20 May. The jury's non-voting Chair was curator Lewis Biggs, and the jurors were artists Zhang Enli, Lisa Milroy, Mali Morris, Amikam Toren and Wang Xingwei. We are honoured to display the dynamic prizewinners from this exhibition at the Walker. Our thanks go to Lewis and Wang DaWei, Dean of the College of Fine Arts, Shanghai University, for their contributions to this catalogue. We would also like to thank Lingmin (Director of Overseas Arts Projects, in Wang DaWei's Faculty) for her energy in the smooth running of the Chinese project.

There are 50 works displayed in the *John Moores Painting Prize* this year. As usual the subjects and styles are diverse. There are new exhibitors and some returning ones. In combination, these elements make for a wonderful exhibition.

Joanna Laing
John Moores Liverpool Exhibition Trust

Sandra Penketh
Director of Art Galleries,
National Museums Liverpool

The jury

Tom Benson
Artist

Zeng Fanzhi
Artist

Chantal Joffe
Artist

Tim Marlow
Director of Artistic Programmes,
Royal Academy of Arts

Lynette Yiadom-Boakye
Artist

Photo: ZENG Fanzhi Studio

Tom Benson

Tom Benson is a London-based artist. He makes paintings, drawings, installations, prints and books. In his work materials are put to specific use, incorporating both old and new technologies and processes. His recent paintings tend to make use of an open grid structure, overlaid with collaged materials. A cross-wiring between one work and another gives rise to a situation where the manner of making recedes to allow a space for thoughts and ideas to hang together. The matter and materiality of the work is propositional: what it is to see, to touch, to move, to experience position, light. He is a graduate of the Royal College of Art and St Martin's School of Art. Recent solo exhibitions include: Stiftung für konkrete Kunst, Reutlingen, Germany, (2006), Concept Space, Shibukawa, Japan, (2010), Hidde van Seggelen Gallery, London, (2012), and Sleeper, Edinburgh (2013).

Zeng Fanzhi

Zeng Fanzhi was born in 1964 and is based in Beijing. The varied subjects of his oil paintings include slaughtered animals, icons from art history, consumerism, the 'mind landscapes' of human beings and recent Chinese history. Since 2010, Zeng has sometimes exhibited his own woodcarvings, etchings and sketches alongside his paintings. The artist says of his work, "I am very interested in fashion and about style, especially in the Nineties, because at that time everything was new to us." Zeng has enjoyed constant critical acclaim since the 1990s, exhibits internationally and is one of the world's top ten contemporary artists by revenue. He has been represented by Gagosian Gallery since 2011 and has held exhibitions with them in London and Hong Kong.

Photo: © Felix Clay

Photo: Johnnie Shand Kydd. Courtesy: White Cube

Chantal Joffe

Chantal Joffe is an English painter based in London. She is interested in the complex lives of modern women and the roles that their bodies, children and fashion take within their narratives. Her expressive paintings can be up to three metres high and have been described as possessing an 'everyday awkwardness' and a 'deceptively casual brushstroke' as well as challenging our preconceived ideas of feminist art. Joffe has been exhibiting in prestigious exhibitions since the 1990s, including the *John Moores Painting Prize* in 2002. She studied at Glasgow School of Art and the Royal College of Art. She exhibits internationally and is represented by Victoria Miro Gallery, London.

Tim Marlow

Tim Marlow was Director of Exhibitions at White Cube from 2003-14 and earlier this year became Director of Artistic Programmes at the Royal Academy of Arts. Over the last decade he has worked with some of the most important and influential artists of our time including Chuck Close, Jake and Dinos Chapman, Tracey Emin, Damien Hirst, Anselm Kiefer and Doris Salcedo. He is also an award-winning radio and television broadcaster and has presented more than 100 documentaries on British television. Tim was the founder editor of *Tate* magazine and is the author of numerous books and catalogues. He has lectured on art and culture in more than 40 countries.

Photo: Marcus Leith, London

Lynette Yiadom-Boakye

Lynette Yiadom-Boakye is a London-born artist of Ghanaian descent. A painter, her imaginary scenes populated by invented people prompt questions of how we interpret paintings. Yiadom-Boakye was an exhibitor in the *John Moores Painting Prize* in 2004. She was nominated for the 2013 *Turner Prize* and was the first Black woman to be shortlisted in the competition's history. Recent exhibitions include the *New Museum Triennial*, New York, in 2012, and a major solo show, *Extracts and Verses*, at Chisenhale Gallery, London, also 2012. She exhibited in the 2013 *Venice Biennale*, where she won the Future Generation Art Prize. Her most recent solo exhibition was this year at Yale School of Art's 32 Edgewood Gallery in New Haven, Connecticut, and she will have a solo show at Jack Shainman Gallery, New York, in autumn 2014. She is represented by Corvi Mora in London and Jack Shainman Gallery.

Painting is a Character

By Zeng Fanzhi

Painting reveals character. It not only shows the greatness in the ordinary, but also the ordinary in greatness. From an ancient Chinese perspective, the highest achievable state of aesthetics is described as 'you' (as the Chinese character 遊 is pronounced). 'You' is an exceptionally high level of attainment. Only if one's technique and degree of skill has reached a certain level can one be freed from oneself; and only then can one reach this ultimate free state of mind.

Achieving this state will lead an individual to reach a stage of synchronicity between hand and mind in which artistic creation becomes a part of oneself: this is the creation of complete freedom. Such freedom is an ultimate form of completion - the completion of a great aesthetic beauty.

At this point, the artwork itself now holds a cathartic quality: this language of painting becomes the language of life, which in turn leads the observers to attain a certain state. This state mirrors both the artist's vision and their aesthetic character. This is how I discover a good painter.

Today, we live in an era of globalisation and information overload. Cultures and economies are intertwining, but in general contemporary art is dominated by Western theory and history. I believe that we should discover real beauty, love and truth from our distinctive natures, and celebrate the power carried by those elements. It is in this way that a real artist can be celebrated.

Lynette Yiadom-Boakye: Q & A

You exhibited a painting, *Mature Love Poetry*, in the 23rd *John Moores Painting Prize* in 2004. Where is that painting now?

I think it's rolled up in my studio. When I exhibited in the *John Moores* I was between studios and had no storage space either, so when it came back I had to take it off the stretcher. I keep meaning to get it out. It will probably need some restoring by now.

How do you think that the painting stands up today? Did you feel that it was one of your strongest pieces at that time?

I'm still very pleased with it. A lot of things have changed since then but it was an important moment in terms of developing my use of colour. I see a very strong link between that work and several things I've done since. In that regard it was seminal. It was definitely one of my strongest works at the time, although perhaps that wasn't hard to be!

What were your thoughts about the rest of the exhibited works in the *John Moores* you exhibited in? Did you feel it successfully reflected painting at that point in time?

I mostly remember being really excited about being in there. I was just out of art school so the idea of a career as an artist was somehow still an abstract one. It is hard to define it as having represented painting at that time as it is hard to say that of any show. Who knows what else was out there? What I will say is that the exhibition was diverse and dynamic and that was exciting to be a part of.

How did you feel then about entering a competition in which the process was anonymous, judged on the merits of only one painting, with no information about the artist, or wider context provided for the work?

I didn't think very hard about that. In fact, I'm not sure I even read any of the small print. I never expected to get in. I was recently out of college and applying to lots of things. It was reassuring to discover that later; that it was decided purely on the merits of the work.

Was exhibiting in the *John Moores* a springboard for you? What was its significance? How did it impact upon your work?

It didn't impact on my work in itself but I would say that inclusion in the show was a wonderful confidence boost to me personally. The recognition of my work by people I respected meant a lot to me and, at that very early stage in my career, the chance to show alongside established painters was exciting.

Has your opinion on the *John Moores* changed since you have been a part of the judging process?

Not especially. Only in the sense that I know what the process is.

In the current judging process, are you judging from a personal point of view or are you trying to be more objective and, for example, view the works from the context of painting in Britain today? What are your criteria?

It's very difficult to explain. Essentially, the personal point of view, likes and dislikes, can only ever be a starting point. We each had to get beyond that through discussion. That's why it is important that there is more than one judge, and that we are all completely different in terms of personal taste. I tried to look at each artist's work in terms of trying to understand what they were trying to achieve in the work.

Also, it's about appreciating that we're only ever seeing an extract from a whole practice. That is the real challenge. We're so used to looking at a whole exhibition of an artist's work; understanding it through the dialogue that exists within a body of work. It's often very difficult to assess one thing taken completely out of context. It is almost impossible to have hard and fast 'criteria'.

In addition, it is a bit lofty to speak of 'painting in Britain today' as though everyone is attending the same class and graduating from it. There is so much going on in painting out there, as with any art form, that it's unfair to make such a claim. We make a selection from the artists who submit works, and although there is a

group of us and we need to reach some consensus, there is always an element of subjectivity. A different group of judges could make a completely different selection. My hope is that we have made a selection that is diverse, engaging and powerful. I don't think we need to claim more beyond that.

There is a lot of debate around whether or not the paintings in the *John Moores* should have interpretation with them - we don't normally have interpretative labels, but visitors often ask what the paintings are about, or what they mean. Are you 'for' or 'against' interpretation of this kind?

I'm not a huge fan of this kind of labelling, primarily because I don't think everyone likes to be told how to look at a painting. I totally understand the argument for them from an educational point of view, but that is where the catalogue, with its artists' statements, is a useful resource. One has the option of reading about an artist's intentions or getting more of a sense of what the painting is about, but in isolation from the experience of looking at it.

I think it is important that painting is experienced through the senses; a written explanation next to the work can interfere with that.

Lynette Yiadom-Boakye's painting *Mature Love Poetry* can be viewed on the Walker Art Gallery website.

Tom Benson and Tim Marlow In Conversation

TM One of the interesting aspects of judging the *John Moores* at the Walker is that one is physically made to consider the historical context of the prize. I don't necessarily mean those wonderful galleries of European painting from the 13th century to the present - although we might explore what that means later on. Specifically, I mean the galleries of former *John Moores* prizewinners, from Jack Smith in 1957 to Sarah Pickstone last time in 2012. I have really been struck by the fact that almost every painterly approach and style on view in that triumphal procession of paintings has been reflected in the vast array of submitted works this year, and wondered if that pluralism in any way surprised you or whether you feel it's a self-evident orthodoxy today?

TB It seems clear we're in a multi-dimensional, pluralistic situation, in flux, but the terms of the most interesting work are still in contention - what's being developed and what it gives rise to. So, and as you say, there are many overlaps with previous prizewinners...

TM I like the idea of pluralism in flux. It sounds Bergsonian, but of course he was developing his theories of dynamic flux just as the monolith of modernism was emerging. Do you see any potentially dominant trends in contemporary painting on the basis of what you've encountered in Liverpool?

TB Not easy to be clear-cut. A lot of the work we saw sits squarely within familiar conventions. There's a playful riffing off 'rival' positions, casting a surprising shadow over many images. Unexpected questions abound in the best works... It's fascinating to see how painting is opening out onto other spaces, off the wall, contesting (its) terms; how stasis and temporality is brought into play. Saying that, there's a definite spill into pixilated space (not really a surprise), grisaille (who would have thought?), photographic mimesis (still) and pop (everywhere).

TM The idea of opening out into other spaces is very interesting. It implies a generosity or receptiveness which reminds me of what happened to sculpture at the end of the 60s - what Rosalind Krauss described as 'an expanded field'. I'm not in any way trying to imply painting is lagging behind but I wonder whether you feel this opening out is largely self-critical

on the part of painters generally, or whether it represents a kind of necessary retrenchment? My own instinct is the former - but it could be seen as a defensive rearguard action to reclaim lost territory, I suppose.

TB If it counters complacency, self-criticality is a good thing, obviously... I'm interested in the porosity a work can have, and how it might deal with a subject beyond its formal makeup...

We're familiar with the terms of 1960s Modernist painting - not such an issue today (which isn't to say they don't hold water for some). As for the expanded field of sculpture, the dissolve of a work's autonomy, its bearing on and reciprocity to place - these are relatively underexplored areas in painting (because of the sanctuary of the studio?) Of course there are developments using painting that preceded the expanded field... El Lissitzky's explorations into presentational environments, Katarzyna Kobro's work (painted objects), Kurt Schwitters' painted assemblages, Piet Mondrian's last studio with colour elements attached to and traversing the space, Matisse's large scale friezes.

Then we have the expansiveness of Robert Ryman's work, Katherine Grosse's colour hazes... who would have thought it?

TM Who indeed? Although Ad Reinhardt did describe painting as environment in the early 60s, even as the formalist idea of modernism held sway. It's significant - and appropriate I think - to consider contemporary painting predominantly within the context of the last century, but I wonder about longer histories - something I alluded to at the beginning which is certainly part of the landscape any viewer of the *John Moores* has to negotiate, consider or consciously avoid. You have to walk through part of the history of Western painting to get to our selection. But do you find anything other than atavistic connections at play, or are you conscious of a less fractured history than modernism once claimed?

TB It's also significant that Ad Reinhardt was a scholar of Islamic and Buddhist art, who, from time to time, advised the Metropolitan Museum on their acquisitions. I think we are able to see that these interests had a profound effect on his paintings.

I doubt there are many painters working today who don't share a keen interest in painting that's pre - 20th century. That same negotiation takes place when a viewer contends with contemporary painting, such as those we've seen and selected. Painters are always squaring off against what came before, conducting a dialogue and furthering a debate. To a large extent it's a collaborative and contentious process - influences absorbed, influences rejected - which amounts to the same thing. As for painting's longer histories, they're being overlaid and rewritten all the time. If we think about atomised space then look at late Rembrandt; he dissolves the figure/ground problem in the 17th century. Saying that, it's not often that we get to see such a highly evolved, personalised language.

Do you think there's any onus on contemporary artists to know something about and contend with the histories of painting that came before them?

TM Onus might be putting it too strongly but I think there's a deep-felt receptiveness to the past that is stronger among painters than any other visual medium I can think of. Since painting's death-rites were (spuriously) read in the late '60s, painters have been acutely aware of their medium's vulnerability and its resilience too. It's certainly clear that painting will never be the pre-eminent visual medium it once was, but then again nor will any other visual medium ever dominate in the way that painting once did in Western culture. There's a confidence now about contemporary painting that has evolved over the past decade which I think comes from a relaxed but highly engaged relationship with the history (or as you say - with greater rigour - histories) of painting. Much of what we've looked at in judging this year's *John Moores* has explicit historical underpinning but relatively few paintings seem overburdened by the past.

The other aspect of history that intrigues me is the personal one. We have to judge the submissions without any back stories. It is what might be described as a tightly guarded process of controlled anonymity. Obviously we recognise the work of certain artists but in the main we are asked to work in a relative vacuum. I'm not suggesting this is the wrong approach - it opens up the competition

and artists are judged on what is submitted rather than their broader reputation. But it does place more pressure on the judges to try and contextualise work with no hard evidence bar the single art work in front of them. I can't help feeling that there are artists for whom personal context is essential.

TB Well, yes - personal history does give rise to the work, the work being an equation of experience, intention and point of view. And biographical details (if to hand) do enrich our understanding of a given work - viewing something cold poses its own challenges. But a part of me wonders if our fascination with lives lived can sometimes overshadow engagement with the density of the work? I don't always want to read a bio before looking and having time to fathom what might be on the surface of a painting, inscribed there. The evidence, motivations, conceits are often right there, writ large, to be grappled with...

TM I didn't mean biography so much as the creative evolution of an artist's career. I totally agree with you that the story and often mythology of lived lives is often a veil through which art can be partially

obscured. But even though most paintings begin with a blank surface, they are also an accretion of past work. I guess if you'd seen Philip Guston's great repudiation of abstraction in 1970 without knowing the context, the impact would surely have been less provocative or meaningful. But the idea that a painting has the potential for profound revelation, and that each work is self-contained as well as part of a continuum, is true I think. I suppose that's the challenge every painter faces when he or she confronts the empty canvas and starts to work...

TB Yes, the challenge is always to make something new. And sometimes that necessitates a rupture, but over time the work - it becomes clear - is as much a part of the painter's thinking as what came before. It operates dialectically, by which I mean, in order to build-up a dynamic energy across the trajectory of the work, the artist's preoccupations must be tested - so an idea is countered by another, maybe antithetical idea, and some sort of synthesis of that encounter then emerges. And that takes the work to the next place.

So, when we encounter Guston or Matisse repudiating the hubris of a

comfortably ensconced reputation -
of work that is too accomplished, too
expected - this is that moment of danger
- that produces a renewal of energy and
gives the work its reality.

And very often the kernel for later work
was there before - as we can see clearly
in the case of Guston. So it's more about
not standing still, it seems, than a seismic
shift.

Even in Guston's case, the release from
those clusters of marks which no longer
provided quite enough oxygen for him,
becomes its own dynamic.

It's a way of thinking and acting through
the work. Those oppositions - be they
larger and more pronounced or not so
pronounced - are, more or less, what
brings complexity to a good painting.

And you wouldn't come up with this over
breakfast. I mean, Guston, say, making
the radical decision to change and to
start painting cartoon-like references
to persecution and the Ku Klux Klan,
to existential angst - a painter doesn't sit
down and think: that's what I'm going to
do today. The work evolves through the

creative activity of making it.

So yes, we can certainly agree on that.

Prizewinners
In alphabetical order

Rae Hicks

Juliette Losq

Mandy Payne

Alessandro Raho

Rose Wylie

Rae Hicks

Sometimes I Forget That You're Gone

2013
Oil on canvas
86.5 x 76.5 cm

When all the elements of a scene are present in a setting but as yet unassembled - as though raw resources in storage - they often still possess all the necessary components which complete the intended picture; all the correct colours and shapes.

Often this unconscious assemblage, through its very dislocation, is at least as powerful as the finished picture. Perhaps this is because it shows the potential for almost infinite combinations and re-workings, with the possibility for new incorporations. Maybe it is also because it betrays the nuts-and-bolts beginnings of apparently organic forms.

For the last couple of years I have been interested in the self-consciousness of the developing Western European landscape, its constant reinvention and the emblems that are on rotational use. I want to approach artifice with sensitivity, with openness to its potential for new perspectives.

Biography

Born in London in 1988, Rae Hicks grew up in Bath, attending City of Bath College 2006-7, and Goldsmiths London 2008-12, with a year at HFBK Hamburg 2010-11. Recent exhibitions (London unless stated) include *New Classics* Elektrohaus Hamburg 2011, *One of the Forgotten* Frameless Gallery 2012, *Crash Open Salon 2012* Charlie Dutton Gallery, *ICE-9* Brixton East 2013, *Summer Exhibition* Royal Academy of Arts 2013, *The Magnolia Cube* 566 Cable St 2013, *Da Sein, Das Ei* Galerie Vorwerkstift Hamburg 2013, *Griffin Art Prize 2013: Shortlist Exhibition* Griffin Gallery (touring), *Triple Sod* (with Will Thompson) Peckham Springs 2014. In *John Moores* 2012.

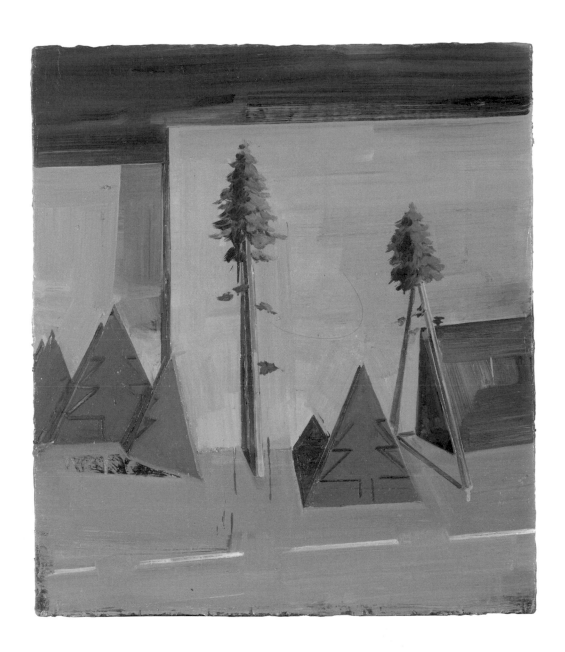

Rae Hicks

Juliette Losq

Vinculum

2012
Watercolour and ink on paper, on canvas
290 x 220 cm

I make large-scale watercolours, including installations, which form immersive or semi-immersive environments into which the viewer may feel they can walk or fall. Through these I aim to challenge the ideas of watercolour as being a medium that, traditionally, holds connotations of portability, is to be used for preparatory sketching, or has associations with domestic scale and use. Using resist, a traditional material of the watercolourist, I work over the surface repetitively as if building up an etching plate, creating multiple painted layers which simultaneously obscure and reveal those beneath. Within these layers I incorporate imagery derived from Victorian 'Penny Dreadfuls', newspaper illustrations, science fiction and horror films. This becomes inextricably woven with the detritus of the marginal areas that I depict. In doing so I aim to evoke an uncertain world in which the uncanny can coexist with the mundane, and where the possibility of confronting what has been repressed may generate at once feelings of creeping malevolence or whimsical curiosity.

Biography

Born London 1978, Juliette Losq studied there at Wimbledon College of Art (WCA) 2004-7, Royal Academy Schools 2007-10. Group shows include *Jerwood Drawing Prize* (Winner) Jerwood Space London (touring) 2005, *Drawing Breath: Surveying 10 years of the Jerwood Drawing Prize* WCA (touring) 2006, *Catlin Art Prize* Tramshed London 2011, *AVA The Collection* All Visual Arts London 2012, *Another Room* R O O M London 2013, *Viewing Room* AVA at The Crypt London 2013, *Epic Fail* Storefront NY 2013, *The Open West* Newark Park Gloucestershire (touring) 2013. Solos include *Lucaria* Theodore Art NY 2012, *Dans la poussière de cette planète* Galerie Arcturus Paris 2013.

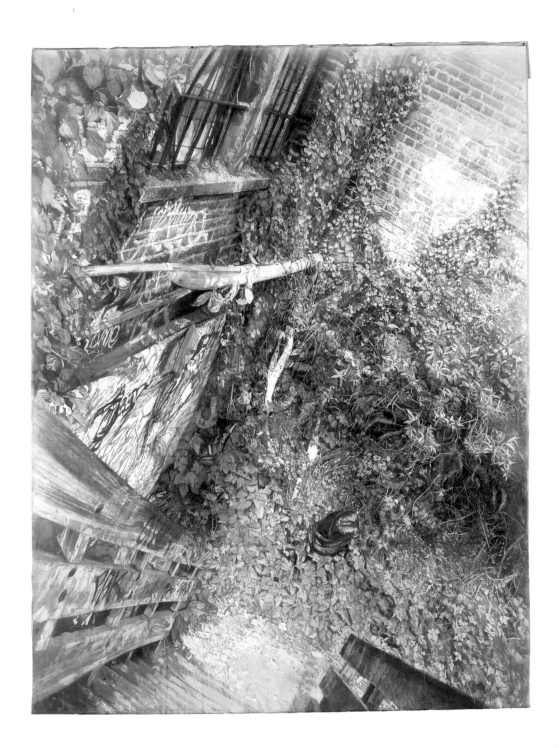

Juliette Losq

Mandy Payne

Brutal

2013
Aerosol spray on concrete with wooden frame
32.7 x 46.5 cm

Over the past 18 months I have been exploring Park Hill in Sheffield, the Grade II* listed council estate and one of Britain's largest examples of Brutalist architecture. The site is currently undergoing regeneration and as such is an interesting place to observe. Part of the estate has been transformed into shiny, luxury flats whilst half remains boarded up and derelict. A small remaining part is still inhabited - the residents remaining resolutely in situ until finally decanted.

I am ever drawn to the un-refurbished parts of the development where the memories and layers of the past are almost tangible. I wanted to create observational paintings that spoke of the desolation and displacement of the established communities and the temporality of the urban landscape.

Spending time at Park Hill reinforced to me that concrete is the unifying link throughout the estate and could be regarded as a potential palimpsest. In the refurbished sites the concrete has been restored to exacting standards; in the old parts it is spalled, weathered and tarnished, which gives it a rawness and beauty of its own. I have been working with materials that are integral to the estate itself, namely concrete and aerosol spray paints.

Biography

Sheffield-based Amanda Payne was born in Pontypool in 1964. After training in Dentistry 1982-95 she studied Fine Art at Sheffield College 2007-10 and Nottingham University 2011-13. Group exhibitions include *Derby City Open* Derby Museum and Art Gallery 2011, 2012, *South Yorkshire Open Art* (Emerging Artist Award) Cooper Gallery Barnsley 2012. In 2013: *Harley Open* (Judges' Prize) Harley Gallery Worksop, *You Are Here* Arundel Room Millennium Gallery Sheffield, *University Summer Exhibition* Djanogly Art Gallery Nottingham, Wirksworth Festival Artists' Trail Derbyshire, *The Threadneedle Prize* Mall Galleries London, *Midlands Open* Tarpey Gallery Castle Donington. Solo *Between Places and Spaces* Tarpey Gallery 2014.

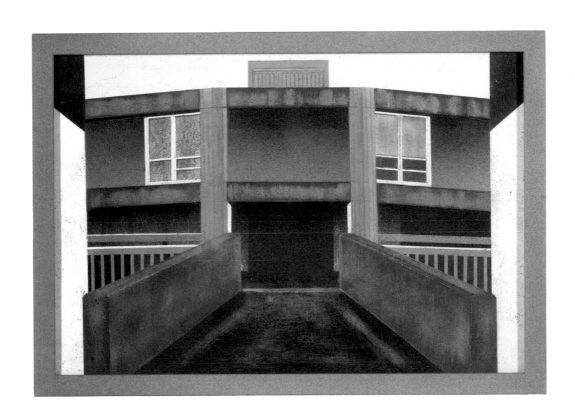

Mandy Payne

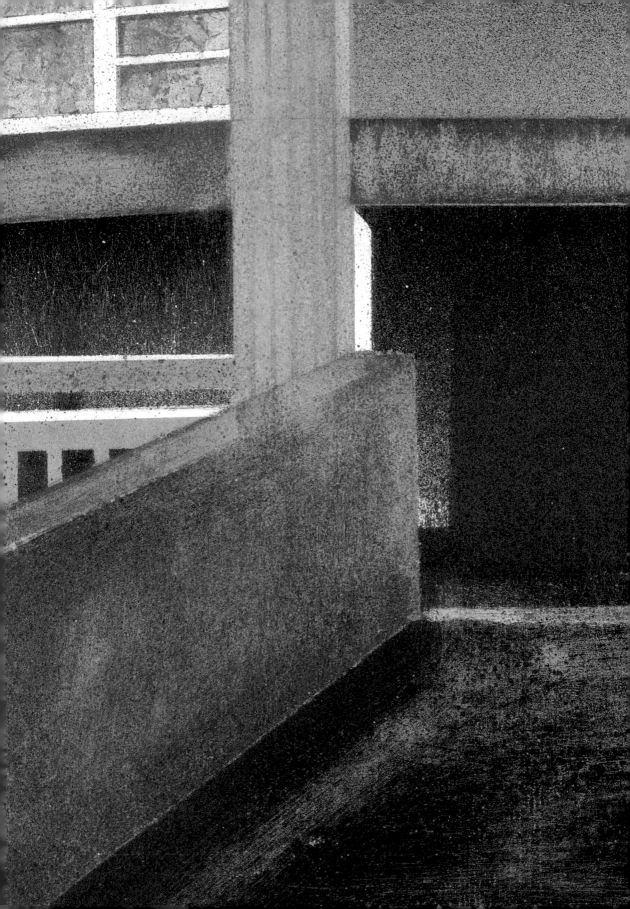

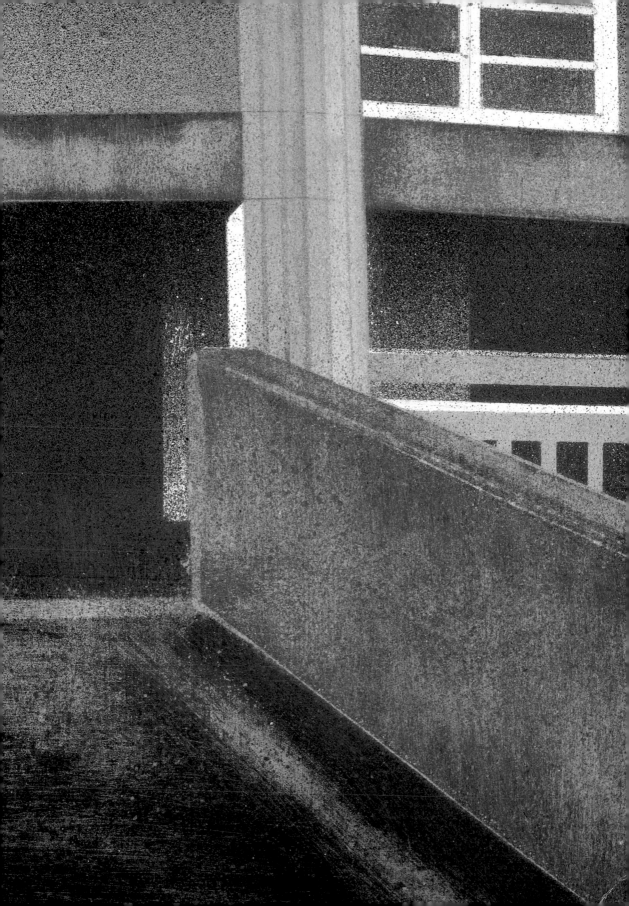

Alessandro Raho

Jessica

2012
Oil on canvas
247 x 170 cm

The painting is of my stepsister, Jessica. I have painted her a number of times, which is something I often do with my subjects. I have frequently painted close friends and family members because the interaction between artist and model is very genuine within these relationships; dressing up and trying out different things becomes as much part of the process as making the painting and it's very comfortable with people you know well.

The clothes in this painting were not Jessica's own. I had an idea about the painted splash that I wanted to investigate. I like realism that feels contrived, or should I say that plays with the idea of its own making, not just depicting a given reality, so inherent in its construction are various signals that acknowledge its fabrication. Choosing patterned or decorated clothes in combination with the white 'monochrome' background gives me a chance to make a painting that is both abstract and figurative.

It is important to me that the portraits feel modern, are of our time. I want these pictorial devices to be moving, to have an emotional effect to do with painting's artifice, as well as its capacity for description.

Biography

Born Nassau, Bahamas 1971, Alessandro Raho attended Goldsmiths College London 1991-4. Exhibitions include *Brilliant!* Walker Art Center (WAC) Minneapolis 1994, *Painting on the Move* Kunsthalle Basel 2002, *Wall Rockets* FLAG Art Foundation New York 2008, *Great Britons* Smithsonian Institution Washington DC 2007, *Painting Show* Eastside Projects Birmingham 2011, *Knock Knock* Jerwood Gallery Hastings 2013, *I Cheer A Dead Man's Sweetheart* De La Warr Pavilion Bexhill-on-Sea 2014. Has had numerous solo shows. London's National Portrait Gallery commissioned a portrait of Dame Judi Dench, 2005. Other collections include MOMA New York, WAC Minneapolis, Seattle Museum of Art. Lund Humphries monograph published 2011.

Alessandro Raho

Rose Wylie

PV Windows and Floorboards

2012
Oil on canvas
181 x 334.5 cm

Usually I paint something I've seen, but I may fiddle with the scale, context, and rules of gravity. I draw from observation, memory and with 'conceptual projection' - how a stereotype would look from the un-stereotypical view, or if made from a written list of observed particulars, then that list illustrated.

The paintings often start from my drawings, but anything can change, depending on the way I feel about how it is, or if I know what that should be. The drawings can come from the excitement of anything I've seen, but particularly from film (the swapping of one art form from another), newspapers, and memory of personal events. My main interest is how the work looks, but meaning - politics, issues, story, and so on - remains as part of the structure of making a work, an act which is both personal and contemporary.

In my life I stack and heap up notations of experiences, and often repeat this process in combinations of paintings as I see them in my mind. The flexibility of leaving bare canvas and 'floating' imagery allows these regroupings and linear-continuations to happen easily in a picture hang, while also permitting individual paintings to keep their own particular, independent identity.

Biography

Born Kent 1934, Rose Wylie attended Folkstone and Dover School of Art 1952-6, Royal College of Art London 1979-81. Exhibitions include *Women to Watch* NMWA Washington DC 2010. Solos: *What with What* Thomas Erben NY 2010, *Picture on the Wall* Michael Janssen Berlin 2011, *After Daphne* Rosenwald - Wolf Philadelphia 2012, *Rosemount* Regina Moscow 2012, *Big Boys Sit in the Front* Jerwood Gallery Hastings 2012, *Woof-Woof* Haugar Museum Tønsberg 2013, *Henry, Thomas, Keith & Jack* UNION London 2013, *BP Spotlight: Rose Wylie* Tate Britain London 2013, *What Means Something* Choi & Lager Cologne 2014. Collections include Arts Council Collection. Exhibitor *John Moores* 1991.

Rose Wylie

Artists

Phil Ashcroft
Jo Berry
Jane Bustin
James Byrne
Wayne Clough
Paul Collinson
Christopher Cook
David Dawson
Robin Dixon
Fiona Eastwood
Robert Fawcett
Tom Hackney
Susie Hamilton
Charlotte Hopkins Hall
Barbara Howey

Thomas Hylander
Andy Jackson
Nicholas Kulkarni
Rachel Levitas
Mackie
Hynek Martinec
John McSweeney
Nicholas Middleton
Reuben Murray
Tony Noble
David O'Malley
Daniel Pettitt
Frank Pudney
Emma Puntis
Tim Renshaw

Neal Rock
Conor Nial Rogers
Karen Roulstone
Gideon Rubin
Alli Sharma
Mark Siebert
Mike Silva
Rebecca Sitar
Ian St. John
Lexi Strauss
Trevor Sutton
Trisant
Covadonga Valdés
Roxy Walsh
Carlos Zuniga

Phil Ashcroft

Crockett

2013
Acrylic on canvas
120 x 80 cm

Phil Ashcroft's specific form of gestural, emotive abstraction combines flattened out 80s style art deco and graffiti influences with references to American abstraction which often threaten to overwhelm the upper sections of his canvases. But it is an overtly Post-Modern type of abstraction, one that appears to forefront process and gesture but is in fact computer-generated translations of gestural painting reproduced as painting.

In other paintings, the work is entirely abstract but it is as if he has cropped or zoomed into the image, suggesting digital manipulations re-presenting or editing Modernist formats. This is further reinforced by the references to vector graphics and geometrical primitives in Ashcroft's work, graphics based on mathematical expressions which are used to communicate non-subjective, procedural routes into abstraction at odds with the historical overtly-subjective precedents of Abstract Expressionism.

(Paul Hobson, Director, Modern Art Oxford, from *Phil Ashcroft: Solar System Parameters*, 2013)

Image credit - Photographer: Joe Plommer

Biography

Born Farnham, Surrey in 1970, Phil Ashcroft lives and works in London. Attended Harrow College of Art & Design 1989-92, St Martin's School of Art 1992-4. Group exhibitions (London unless stated) include *Contemporary Art Society's ARTfutures 2005, 2007* Bloomberg SPACE, *Celeste Art Prize 2007* Old Truman Brewery, *The Golden Record* Collective Gallery Edinburgh 2008, *Deptford X* 2009, *No Soul for Sale* Tate Modern 2010, *Intervention Intervention* Fishmarket Gallery Northampton 2011. Solos include *Nitro Deluxe* Deptford X 2001, *Yeti In Hong Kong* EXIT HK 2005, *Toxicity* Margaret Harvey Gallery St Albans 2006, *Galácticos* Gamma Transport Division Edinburgh 2013. Collection: The New Art Gallery Walsall.

Phil Ashcroft

Jo Berry
Untitled 2013

2013
Acrylic on canvas
91.3 x 121.8 cm

My work deals primarily with the authenticity of the image in the digital age, building new layers into the process of representation. I edit and re-photograph found photographic images that usually contain an element of unreality, such as fancy dress costume packaging, 3D bookmarks, advertising images and packaged scale models. The resulting paintings take on new, unsettling meanings and truths.

Recently, my work has explored images from stock photography websites, deliberately selecting images from the bottom end of the 'popular' category. This vast debris of unwanted imagery seems unable to persuade anyone to engage with it. In one sense, perhaps these images have reached the end of their lives, but by resurrecting elements of them using a painstaking, painterly treatment, they are given new meanings.

Biography

Jo Berry was born in Halstead, Essex in 1970. She studied at Manchester Metropolitan University 1989-92 and lives and works in Cardiff. Group exhibitions include *Open Show 2008* Surface Gallery Nottingham, *If You Build It They Will Come* g39 Cardiff 2008, *Last Days of the Empire* g39 Cardiff 2010, *Wales International Painting Prize: BEEP 2012 - Through Tomorrow's Eyes* Volcano Swansea 2012, *Welsh Artist of the Year* (Highly Commended) St David's Hall Cardiff 2013 and *Hot-One-Hundred* Schwartz Gallery London 2013. She was included in the *National Eisteddfod of Wales* Ebbw Vale 2010, Vale of Glamorgan 2012.

Jo Berry

Jane Bustin

Christina the Astonishing

2013
Oil, acrylic and copper on two wooden panels
40 x 35 x 7 cm

The paintings are made as sequential, monochrome abstract works, executed in various media on a variety of surfaces. I methodically place panels of varying shapes, colours and paint quality, fabrics and objects, side by side, until they create their own sense of balance. Whilst the final painting resembles a formalist abstract construct, the choice of colour, paint and material used directly reflects the psychological concept of the subject.

The paintings take reference from: 14th-century frescoes, 15th-century Flemish portraiture, Masaccio, Velazquez, Vermeer, Francis Bacon, French literature, Modernism, paper, wood, copper, latex, linen, silk, gesso, grain, neon traffic signs, sweet wrappers, cosmetics, Japanese ceramics, hardware stores and gem stones. The painting process for me is methodical, intellectual, instinctive and transcendent.

Biography

Born Hertfordshire 1964, Jane Bustin attended Portsmouth University 1983-6. Exhibitions include *Darkness Visible* Southampton City Art Gallery 2007, *Summer Exhibition* Royal Academy of Arts London 2011-13, *Back and Forth* B55 Gallery Budapest 2012, *Mostyn Open 18* Oriel Mostyn Llandudno 2013, *Jerwood Drawing Prize 2013* Jerwood Gallery London (touring), *Mud and Water* Rokeby Gallery London 2013/4. Solos include *Unseen* British Library London 2009, *Anatole Notes* Testbed 1 London 2012, *The Astonishing* Austin Forum London 2014. Curated *A Little Patch of Yellow Wall* Lion & Lamb London. Collections include V&A London, YCBA New Haven, Ferens Art Gallery Hull. Exhibitor *John Moores* 2012.

Jane Bustin

James Byrne

Book

2012
Oil on canvas
37.6 x 45.3 cm

This painting is one of a series of small works which have their origins in a range of table top objects. These items were in the studio to stimulate action and promote engagement with the activity of painting. Interestingly, a book was not one of them. I have long been interested in the way the activity of painting - the process, materials and actions - can give rise to images which confound intentions but present greater truths. Images arriving out of this activity seem to sit more securely and naturally in the paint and on the surface.

Biography

Born in Birmingham in 1948, James Byrne attended Birmingham Polytechnic 1982-8. Group exhibitions include *English Expressionism* Warwick Arts Trust London 1984, *21for21* Ikon Gallery Birmingham 1984, *Work selected from Birmingham Studios by Pete McCarthy* Lanchester Gallery Coventry 1989, *Bill Gear Past and Present Friends* Birmingham Museum and Art Gallery 1989, *Jerwood Drawing Prize* 2003 Jerwood Space London, *The Art of Birmingham Part 2* (1940-2008) BMAG 2008/9. Solos include *James Byrne Paintings* Ikon 1986, *James Byrne Monotypes* Ikon Touring 1986, *Field Series: A Sense of Place* MAC Birmingham 1999, *James Byrne: Painting and Process* Aston Webb Rotunda University of Birmingham 2012.

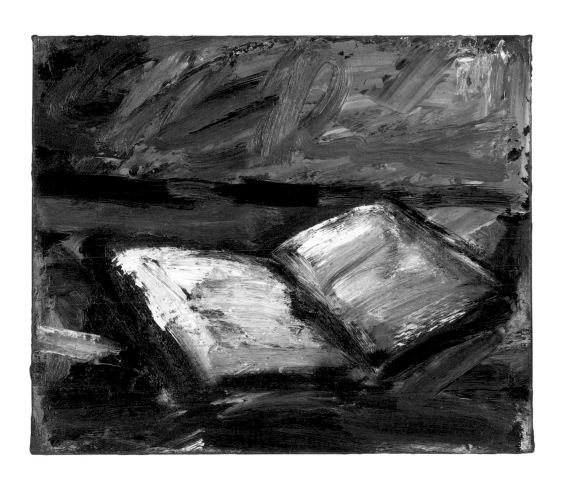

James Byrne

Wayne Clough

Citadel

2013
Oil on paper with mount and light grey frame
45 x 47.5 cm

I am a painter who explores how photojournalistic approaches in the press construct histories. Images of trauma and social upheaval are frequently presented to recall events which shape collective memory.

Citadel is a retrospective detail of one of the world's most hazardous nuclear sites, courting controversy for over 60 years with ongoing radiological leaks. In an attempt to avert a potential energy crisis, the government has recently approved plans to build two new nuclear reactors in the UK.

Biography

Born Bradford 1975, Wayne Clough attended Bradford College 1998-2001, Wimbledon School of Art London 2004-5. Exhibitions include *Whatever happened to the Leipzig Lads?* (curator, with James McMeakin) Waterloo Gallery London 2006, *Histories* (curator, with James McMeakin) Foss Fine Art London 2008, *Rhizomatic* Departure Gallery Southall 2010, *Royal Watercolour Society Open* Bankside Gallery London 2011, *Creekside Open* (selectors Phyllida Barlow, Dexter Dalwood) APT Gallery London 2011, *Group Show* Alma Enterprises London 2013, *Crash Open Salon* Charlie Dutton Gallery London 2013, *BP Portrait Award 2014* National Portrait Gallery London (touring). Exhibited in *John Moores Painting Prize 2012* (special commendation by the Jury).

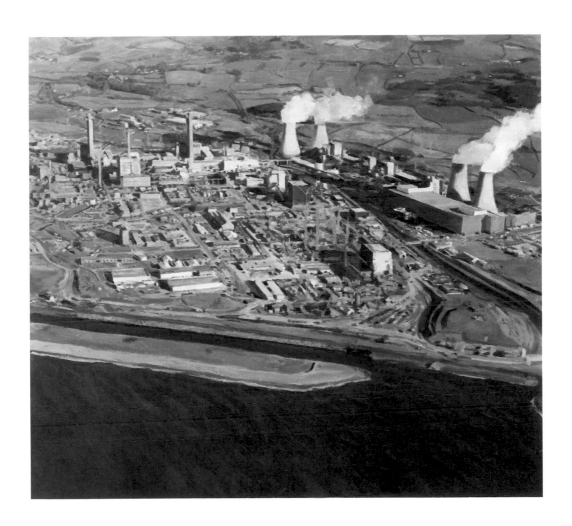

Wayne Clough

Paul Collinson

Et in Arcadia lego

2013
Oil on canvas
122 x 183.5 cm

Et in Arcadia lego makes use of Poussin's picturesque elegy. Two figures turned to stone, one apparently in a leprous condition (such are the ravages of time), contemplate the work of the unseen artist. The stylised death's head is a modern take on the *memento mori*, bringing with it the usual implications of mortality. In Poussin's original the Latin *ego* (the 'I am', a reference perhaps to the tomb's occupant, or the possibility of death) is rendered within a carved inscription by some unknown artist; here it has been replaced by the spray-canned *lego* - 'I read' - and becomes a more active presence by the artist. The armoured vehicle atop the plinth/tomb is a reworking of Ian Hamilton Finlay's work on the subject of the *panzer* in Arcady. My tank appears to fend off the sale of Arcadia; its canon points towards the signage for the usual exciting development opportunity, whilst being taken over by Nature.

Biography

Paul Collinson was born in Hull in 1959, studying there at Humberside Polytechnic 1989-91. Group shows include *The Miniature Worlds Show* Jerwood Space London 2006, *The Really REAL* Python Gallery Middlesbrough 2009, *Situation Critical* Wirksworth Festival Derbyshire 2011, *A Modern Romance* 20-21 Visual Arts Centre Scunthorpe 2012. Solo exhibitions include *REALLY...* RED Gallery Hull/20-21 Visual Arts Centre 2008, *IP-ART* Wolsey Art Gallery Ipswich 2009, *England's Favourite Landscape* Artlink Gallery Hull/Myles Meehan Gallery (Darlington Arts Centre) 2011, *England's Favourite Landscape* Crossley Gallery Dean Clough Halifax 2013.
In *John Moores Painting Prize 2012*.

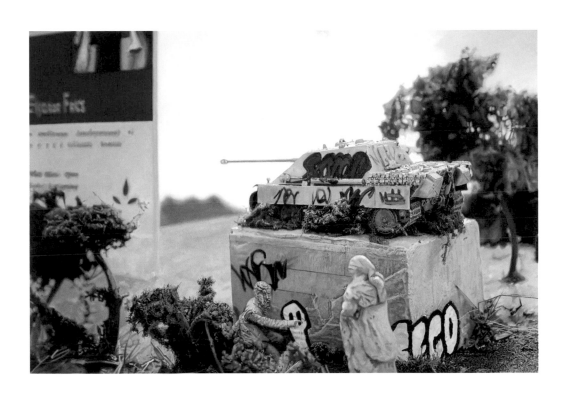

Paul Collinson

Christopher Cook

Vanity Totem

2012
Graphite powder, resin and oil on linen
58.5 x 43.2 cm

My painting has been monochromatic for over a decade, using graphite powder dissolved in resin and oil. Within this limitation I have found improvisational freedom, and here in *Vanity Totem* the final image has evolved from repeated re-workings, allowing the idea to form gradually, resulting in a complex surface patina.

Vanity Totem is one of a sequence of works made on linen, around the theme of 'obscure mirror', employed to consider suppressed motivations (such as vanity) in a consumer-led society. As in many recent images, I embarked with notions of the Rococo (an epoch in which the mirror became an important emblem) but these elements were subsequently pared down and pushed away from the centre, leaving merely a vestige of their elaborate beginning. Made with fingers, the totem element remains strongly indexical, with suggestions of physical stroking.

Biography

Christopher Cook was born in North Yorkshire in 1959 and studied at the University of Exeter 1979-81 and the Royal College of Art London 1983-6. Solo exhibitions include *Against the Grain* Art Museum Memphis USA 2004, shows at Yokohama Museum of Art Japan 2005 and Today Art Museum Beijing China 2007, *Aerial Jetty* Fine Art Society London 2009, *Concrete Firmament* Mary Ryan Gallery New York 2010, at Langgeng Foundation Jogjakarta Indonesia 2011, and *A Sign of Things to Come* Ryan Lee Gallery New York 2013. Exhibited in *John Moores 21* 1999 (Prizewinner).

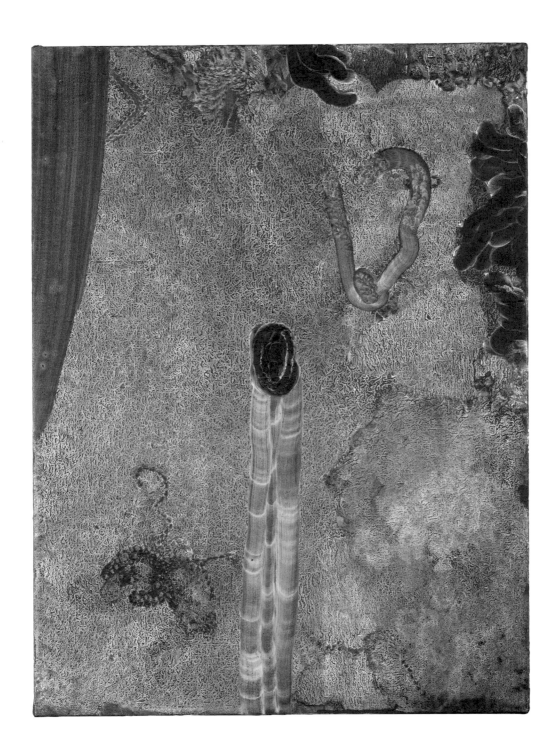

Christopher Cook

David Dawson

18 45. April 7th. 2011

2013
Oil on linen
165.5 x 203.5 cm

I always want a sense of the world in my paintings.

I like using contemporary real life information as the source and the subject matter.

By looking out of my studio window I have an ever present subject to paint and which I can keep referring back to, finding more information, spending months, seasons, and now years watching, observing and making decisions about a very specific location.

This specificity, in turn, gives me a more unique sense of place.

Biography

David Dawson was born in North Wales in 1960 and studied at Chelsea School of Art 1984-7 and the Royal College of Art London 1987-9. His group exhibitions include *2 London Painters: Catherine Goodman and David Dawson* Marlborough Fine Art London 2004 and *Freud at Work. Photographs by Bruce Bernard and David Dawson* Hazlitt Holland-Hibbert London 2006.

Solo shows include *Lucian Freud in the Studio - Photographs by David Dawson* National Portrait Gallery London 2004, *David Dawson: working with Lucian Freud* Pallant House Gallery Chichester 2012, *David Dawson: London : Wales : New York* Marlborough Fine Art London 2013.

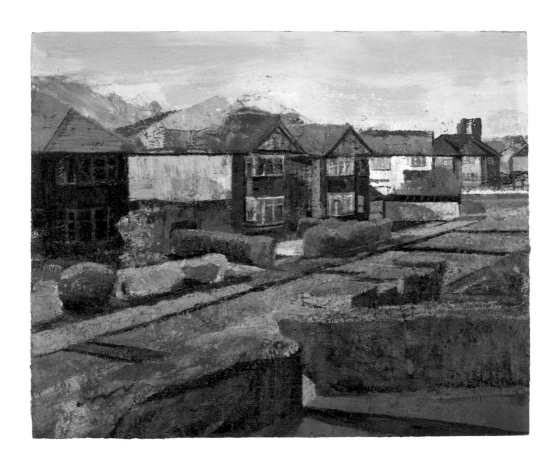

David Dawson

Robin Dixon

Estuary Bridge

2013
Oil on canvas
75 x 55 cm

I paint mainly landscapes. These contain figures which are becoming more prominent in my recent work. I take photographs and collect a lot of postcards and books. I use these as reference material, picking up on details within them.

The paintings are an accumulation of images. I like to rework them so that certain elements remaining can lead me in a particular direction, or prompt me. I might place figures on the canvas and let the painting develop around them, working in layers. Sometimes this process is reversed and the underlying space is established first, with colour or architectural elements.

As I paint, I edit by scrubbing down the surface to varying degrees and then repainting. In this way the figures appear at different stages. There might be a relationship between them but also there is a sense that they might be present at different times.

The places that I depict are in a state of development, transition, or there is an overlapping of uses; industrial sites, housing estates and the spaces in between.

Biography

Born in Harlow, Robin Dixon studied at Nene College Northampton 1985-6 and Maidstone College of Art (Kent Institute) 1986-9. Exhibitions include *Minimal as Maximal* Kontainer Gallery Los Angeles 2004, *Tower of Babel* Limehouse Arts Foundation London 2005, *Jerwood Contemporary Painters 2007* Jerwood Space London (touring), *Salon Art Prize 09* Matt Roberts Arts London 2009, *Deptford X 2010* Core Gallery London, *Creekside Open* (selector Dexter Dalwood) APT Gallery London 2011, *Luna Park* Lion & Lamb London 2012, *MK Calling* Milton Keynes Gallery 2013.

Robin Dixon

Fiona Eastwood

Closed

2013
Oil on board
193 x 93 cm

A veil is presented; a metaphor for the act of painting itself, as the medium is drawn across the support. For every veil portrayed there is the implication something is hidden from view. We surrender to another painterly deception. We believe the illusion. There is something beyond, within touching distance. With a mixture of intrigue and angst I search for a way in, sometimes finding this in the glimpse of a sideways look. The fluidity of the marks, wet on wet, suspends that moment. The painting is quickly opened but stays closed and it always has to be so.

Biography

Fiona Eastwood was born in Rochester in 1983. She studied at Camberwell College of Arts London 2011-14. Group exhibitions include *Irminsul: You Are Lost* Perrott's Folly Birmingham 2011, *The Basement* Shoreditch Town Hall London 2013, *The Provisionals* (curator and exhibitor) The Asylum Peckham London 2013, *Summer Exhibition* Royal Academy of Arts London 2013.

Short-listed for the *Hans Brinker Painting Prize* Hans Brinker Hotel Amsterdam 2013.

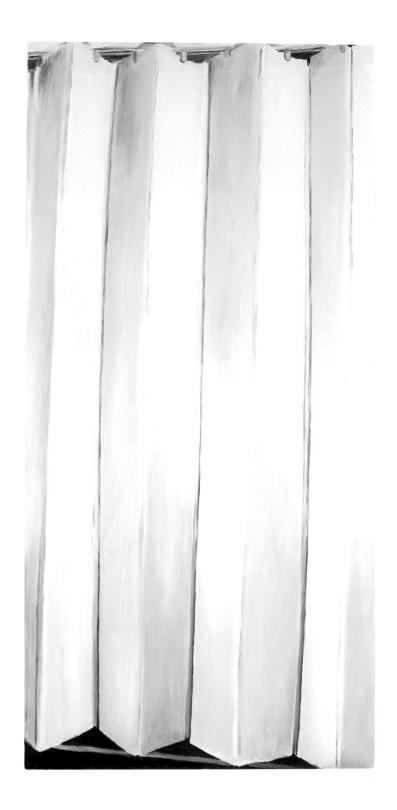

Fiona Eastwood

Robert Fawcett

Frank as Androcles

2013
Oil on copper
34.5 x 24.5 cm

The paintings and drawings I make are usually of people I am very familiar with. My work isn't just about careful observation from life or photographs; it's about my impressions of someone, or slowly gathered memories, and even invention I project onto them.

This painting of Frank is consistent with that - he was the model I used when teaching life drawing. I paid him to sit for me during our lunch break. He had always appealed to me as a subject because, when static, he took on a melancholic gravity. Young models and young people in general do anything to hide their vulnerability, but for people of Frank's age, that's much harder to do. It's this exposed, noble sadness that I wanted to capture.

I saw Frank as a Saint Jerome figure - the old hermit who tames a lion. My girlfriend got confused and started referring to Frank as Androcles - the slave who takes the thorn from the lion's paw - and I let her because I am not attached to titles.

Biography

Born in Cambridge in 1966, Robert Fawcett studied in London at Byam Shaw School of Art 1985-8 and the Royal College of Art 1990-2. Recipient of grants from The Elizabeth Greenshields Foundation 1990, 1996. Group exhibitions include *The Ernst & Young Art Exhibition* Cambridge 1991, *The Discerning Eye* Mall Galleries London 1996, *Robert Fawcett & Paul Hodgson* Terrence Rogers Fine Art /LA International Santa Monica 2001, *Modern Portraiture* Forum Gallery New York 2004 (touring). Solo shows include those at Jill George Gallery London 2002, Terrence Rogers Fine Art/LA International Santa Monica 2003.

Robert Fawcett

Tom Hackney

Chess Painting No. 21
(Duchamp vs. Kostic, Nice, 1930)

2013
Gesso on linen with oak frame
43.3 x 43.3 cm

Painting forms the basis of my practice as a mode, a vessel and a behaviour; a point of exchange between subjective and objective material. The works take an overview of painting as a territory, rather than seeking to take a more conventional, formal engagement with the process of painting. My work is typically generated in response to specific historical material encountered in the process of making, researching and reflecting, and is in itself a contemplative space of hand, eye and mind.

The series of *Chess Paintings* are made by translating records of chess games played by Marcel Duchamp into abstract paintings. A linen ground is divided into an eight-by-eight square grid, about the size of a tournament chessboard. Once a game is chosen, the paths of each of its constituent moves, from opening to endgame, are translated one by one into a single coat of either white or black gesso. Set down in sequence, each new coat is superimposed upon previous ones, so that earlier passages of play become obscured by subsequent developments, as the material plays out through opening, middle and endgame.

Biography

Tom Hackney was born in Taunton in 1977. He studied at Manchester School of Art 1997-2000 and Goldsmiths College London 2006-8. Group exhibitions include *The Knight Turns its Head and Laughs* Stephen Lawrence Gallery London 2011, *Point. Line. Plane.* Hannah Barry London 2011, *Curator's Egg, Altera Pars* Anthony Reynolds Gallery London 2012, *Summer Exhibition* Royal Academy of Arts London 2012, *Motion Capture: Drawing and the Moving Image* Glucksman Gallery Cork (touring) 2012/13, *Essence of Things* Ambacher Contemporary Munich 2013. Solos include *Eye to the Ground* Room Artspace London 2012, *Tremors* BREESE LITTLE London 2013.

Tom Hackney

Susie Hamilton

Freezer

2012
Acrylic on canvas
132 x 132 cm

My paintings focus on the single figure in a wilderness, which may be a frozen forest or an impersonal hotel foyer. I have recently made a series of paintings of solitary old women in the bleak aisles of supermarkets where polished surfaces and sharp lines contrast with dishevelled shoppers, such as the one in *Freezer*. The figures, based on quick drawings from life, are abbreviated to the point of grotesqueness, and bright light bursts on them as painful exposure or destructive energy which can obliterate or eat into the body, transforming it even further. I paint in thin layers of acrylic which transgress boundaries and destroy contours to suggest the figure and its environment succumbing to mutation and mess. Here, the light of the freezer is spilling over the arms and altering the shape of the head. The figure as a whole is melting into an unstable floor which, with its jumbled reflections and angles, is morphing into a flattened pattern of abstraction. I like to turn my representational images towards abstraction so that the named and legible world becomes threatened with nameless shapes. It is an attempt to get behind the everyday to a sensation of menace or mystery.

Biography

Born in London in 1950, Susie Hamilton studied there at St Martin's School of Art 1968-72 and Byam Shaw School of Art 1989-92. Group shows include *Whitechapel Open* Whitechapel Gallery London 1998, *Summer Exhibition* Royal Academy of Arts London 2004, 2009, *Jerwood Drawing Prize* Jerwood Space London 2012, *The Threadneedle Prize* Mall Galleries London 2012. Solos, with several at Paul Stolper London, include *Paradise Alone* Ferens Art Gallery Hull 2002, *New Paintings* Galleri Trafo Oslo 2007, *World of Light* Triumph Gallery Moscow 2008, *Black Sun* Studio Hugo Opdal Norway 2009. In *John Moores 23* 2004. In various public and private collections.

Susie Hamilton

Charlotte Hopkins Hall

A Private Space

2013
Acrylic on canvas
100 x 150.5 cm

The interaction between fellow human beings is a complex ballet crowded with emotion. It is from this minefield that I developed a curiosity in our idiosyncrasies and relationships to reality. I paint a form of psychological drama.

Drawn into my paintings by intricately executed elements, the viewer is then left with a slight sense of unease. Orchestrated by frequently larger than life size figures, this disquiet occurs subsequent to feelings of whether they are inclusive, exclusive or even intrusive.

The impact of negative space is essential. The figures are positioned strategically in various poses and stances within the pure white surface, influencing the painting's character and the impact that it will have. This play with the space, on or off the canvas, creates an imperceptible weight, and gives rise to the possibility of open narratives.

At the core of my paintings, however, are the figures. Either lost within their state of mind, dwelling within their own thoughts, or eagerly seeking attention, they are trying to give sound to their irrevocable silence.

Biography

Born in Geneva in 1979 Charlotte Hopkins Hall attended the Ecole Supérieure des Beaux Arts de Genève 1999-2004. Selected for the Swiss Art Awards Basel 2004. Group exhibitions include *Gorilla Call* Kunstpanorama Lucerne 2001, *Jet-d'eau* Kunsthalle Palazzo Liestal 2004, *London 1.0* Galerie Biesenbach Cologne 2012.

Solo exhibitions include *Charlotte Hopkins Hall* Galerie Schuster Berlin 2005, *Between Anger and Nonsense* Galerie Schuster Frankfurt 2006, *The Thinking Thing* Ferreira Projects London 2008. Collections include BNP Paribas Fortis HQ Frankfurt. Will be curating *London 2.0* Galerie Biesenbach Cologne 2015.

Charlotte Hopkins Hall

Barbara Howey

Orange Sash

2013
Oil on board
40 x 80.1 cm

This painting is based on an image taken from a webpage on Belfast, where I used to live.* It depicts a girl leading the banner on an Orange Order march. I am interested in the idea that this subject has autobiographical references but also that the image has been authored by another hand. I have painted the girl on a small scale, quickly and lightly rendered in thin oil paint. I wanted to suggest an anti-heroic, anti-history painting in which the regalia of sashes and banners are juxtaposed by a child in her anorak, hair neatly pinned back and eyes downcast.

(*From a photograph by Jett Loe)

Biography

Born in Wiltshire in 1954, Barbara Howey attended Leicester Polytechnic 1988-91, Leeds University 1991-2, Norwich School of Art and Design 1996-2001. Taught Norwich School of Art and Design/ Norwich University College of the Arts 1992-2010. Group exhibitions include *Re-Grouping - BendInTheRiver* Workstation Sheffield 2012, *New East Anglian Painting* Art School Gallery Ipswich 2012. *Of Other Spaces* SIA Gallery Sheffield is forthcoming in August 2014. Solos include *Techniques of Memory* OUTPOST Norwich/Huddersfield Art Gallery/ Pearl St Gallery New York 2005/7.

Barbara Howey

Thomas Hylander

Living Room

2013
Acrylic on canvas
80.5 x 107.5 cm

Living Room belongs to a series of paintings depicting memories of a house where I spent a lot of my childhood. This house, grown to mythological proportions in my imagination, is coloured with sentiment, in equal parts, of quiet joy and noisy mourning. I am interested in the slippery nature of the image remembered; the memories of memories. It seems that the further back you go in time, all that's left is patchy, atmospheric sensations of colour, smell and light; old dreams retold and painted in a new fiction.

In my studio I have boxes full of photographs, sketches, clippings and snippets of text, making a veritable compost of words and images. On a whim, they are dug out and become the foundations for paintings. The works are hybrid images, double exposures from photos, memories, of something seen, or an evocative line in a book. I like to think of the finished painting as an archaeological site, in the middle of a dig.

Biography

Born Copenhagen 1970, Thomas Hylander attended Manchester Metropolitan University 1999-2001, Royal College of Art London 2003-4. Group exhibitions include *Pure Contour* Museum Bellerive Zurich 2009, *Fade Away* Transition Gallery London 2010, *Jerwood Contemporary Painters 2010* Jerwood Space London, *Library of Babel / In and Out of Place* Zabludowicz Collection London 2010, *Let the World Slip Away* Lion & Lamb London 2012, *Nordic Focus* Armoury Show NY 2012. Solos include *Thomas Hylander* Vilma Gold London 2009, *Fall Back* David Risley Gallery Copenhagen 2011, *Minuit Vernissage* Grand Theatre Copenhagen 2014. Sorø Kunstmuseum Denmark forthcoming 2015. Collections include Tate, Danish Arts Council Collection.

Thomas Hylander

Andy Jackson

ThrStrps

2012
Acrylic on canvas
121 x 80 cm

My paintings are concerned with composing a multitude of visual effects, encapsulated as abstract mark-making and masked-out isometric planes.

In *ThrStrps* 'squeegeed' applications of pale blue allow darker underlayers to merge into a marble-like effect - reminiscent of X-ray imagery or superimposed film - whilst simultaneously, a seemingly 'foregrounded' light orange plane reveals a window to a separate layer of underpainting.

Like peeling back wallpaper I excavate areas of the painting to reveal hollowed planes exposing previous layers. The picture plane becomes a collection of different procedures, each with their own particular history according to the painting's lifespan in production. As an object *ThrStrps* offers a collection of surfaces suggestive of depth, illusion and the pictorial, operating within and beyond the 'abstract' procedures it contains.

Biography

Born Harrogate 1979, Andy Jackson attended Bath Spa University 1999-2002, Goldsmiths College London 2003-6. Exhibitions (London unless stated) include *Lady Holic* Rod Barton Invites 2007, *SpearCraft* Standpoint Gallery 2007, *Exercise One* 13 Havelock Walk 2009, *I Heart Art* Wassaic Project/WORK NY 2010, *Painting Over* Studio 1.1 2010, *Tom Hackney & Andy Jackson: New Paintings* 10GS 2011, *Painting Over (Part 1)* Studio 1.1 2011, *Mail Please* Blyth Gallery 2011, *SECONDS* The Sunday Painter 2011, *First Come First Served* Lion & Lamb 2012, *Parallels of Latitude* The Drawing Room/UBM 2012, *Prop Up* Johnson's Place 2013, *Handkerchief of Clouds* The Mayor's Parlour 2013.

Andy Jackson

Nicholas Kulkarni

Tracer

2012
Oil on linen
147.5 x 160 cm

When we view a painting we witness an illusion. We suspend our logical minds and allow our beliefs to override our vision. We perceive something to be what it is not. My work seeks to explore how paintings make their viewers willingly consent to an act of deception and questions the implications of this act.

Biography

Nicholas Kulkarni was born in Heswall in 1971. He studied at Northbrook College of Art and Design 1990-1, then the University of Northumbria, Newcastle upon Tyne 1991-4, winning two prizes including TG Stephenson's Purchase Prize. Group shows (London unless stated) include *48 and rising...* Raw Gallery 1994, *Whitechapel Open* Whitechapel Gallery 1996,

Open Studio Space Studios 1996, *Newcastle X* University of Northumbria 1999, *Deptford X* Acme Studios 2001, *Open Studios* Acme Studios 2005.
A solo show *Nicholas Kulkarni: Paintings* was at 198 Gallery 1997. Work in various collections, including University of Northumbria.

Nicholas Kulkarni

Rachel Levitas

Fox with Dahlias IV

2013
Oil on linen
122 x 92 cm

On discovering an abandoned tableau, carefully placed objects are knocked into the air, the Jubilee cloth tugged at, picnic apples and oranges scattered and a vase of exhibition dahlias toppled.

De-constructivist, the fox dismantles our arrangements showing scant regard for any formality. Seeming playful until it delivers that lowered fox glance of utter wildness, its stare checks and reminds us of the rise of other forces, previously suppressed but emerging into disused spaces we have left behind.

The foxes in my recent collection of paintings, *Still Life Disturbed*, while admired for their boldness and beauty, are nevertheless ambivalent symbols of new and opportunistic forces emerging after an economic crisis in society, bringing with it a general repositioning of ideas. In *Fox with Dahlias IV* the creature dismantles a recognised artistic genre, and references the grand displays of produce featured in historic still life paintings collected by the owners of country estates.

Biography

Rachel Levitas was born in London in 1964 and grew up in Durham. She studied at Camberwell College of Art London 1982-6 and the Royal Academy Schools 1990-3. Group exhibitions include *Jerwood Drawing Prize 2010* Jerwood Space London (touring), *Lynn Painter-Stainers Prize 2010* (First Prize) Painters' Hall London, *ING Discerning Eye* Mall Galleries London 2011, *Summer Exhibition* Royal Academy of Arts London 2013, *The Threadneedle Prize* Mall Galleries London 2013. Recent solo shows include *Still Life Disturbed* Campden Gallery Chipping Campden 2013 and *Acquainted with the Night* Gallery Maison Bertaux London 2014.

Rachel Levitas

Mackie

Sorting Station

2013
Oil on canvas
51 x 91 cm

As the story goes, Paul McCartney woke up with the song *Yesterday* buzzing about in his head. He seemed to have written it entirely during his sleep. On the presumption that he had heard it before, he sang it to the rest of the band. They informed him it wasn't an old song. It was a bloody good new one.

I had a similar experience with an idea, in that my subconscious helped me.

Having worked on this idea for five months, it still appeared to be going nowhere. I was stuck on using chiaroscuro toys and iconic horror buildings, like the hotel from *The Shining*, but I couldn't finalise my thoughts. Realising that I had become too enamoured by their presence, I scrapped the concept. A few days later I woke up, suddenly clear that rather than abandoning the concept, I should in fact abandon the toys and the horror film locations, leaving an unusually empty, anonymous architecture. A great place to begin.

Biography

Andrew McIntosh was born in Inverness in 1979. He studied at Telford College Edinburgh 1997-9. He worked largely to commission as a landscape painter 2001-10, then moved to London to pursue a figurative career as 'Mackie'. Group exhibitions include *International Summer Showcase* Hay Hill Gallery London 2012, *Chelsea Art Fair 2013* (Eton Contemporary Art Gallery) Chelsea Old Town Hall London, *20/21 International Art Fair* (Eton Contemporary) Royal College of Art London 2013, *Group Show* Hay Hill Gallery 2013, *Lynn Painter-Stainers Prize* Mall Galleries London 2014. Solo shows include *The Source of Light* Hay Hill Gallery 2012.

Mackie

Hynek Martinec

Every Minute You Are Closer To Death

2013
Acrylic on canvas
185.1 x 244.4 cm

Every Minute You Are Closer To Death depicts an animal that died just a few minutes before.

It confronts the viewer with the question of whether an animal has an afterlife. The creature looks directly at us, albeit motionlessly. The question of what happens in the eventuality of our own death springs to mind. It is this moment of everyday uncertainty that I wanted to represent. The painting contains deliberate references to Dutch still lifes of the 17th century but also, smiling from an iPad, Damien Hirst's diamond skull, suggestive of today's culture and the enduring notion of the *memento mori*.

This is part of a series of paintings I started in 2012. They map my own questions about life and death. Each painting addresses a particular personal experience I lived through and contains hidden references from the history of mankind, together with memorable moments from the past which spoke to me in one way or another. The sepia colour suggests uniformity and simplicity, but there is a confrontation between a traditional medium, the digital format of my camera, and its transmutation to the colours of 19th-century photography. I aim for timelessness, if such a thing is achievable.

Biography

Born 1980 Broumov, Czech Republic, Hynek Martinec attended Academy of Fine Arts Prague 1999-2005, with Middlesex University London 2002, Cooper Union NY 2004. Group exhibitions include *Prague Biennial* 2005, 2009, *BP Portrait Award 2007* (BP Young Artist Award), *2009, 2013* NPG London (touring), *Coal and Steel* Candid Arts London 2012 (touring), *Ein weißes Feld* Schlachthaus Aschaffenburg 2012, *Beyond Reality: British Painting Today* Galerie Rudolfinum Prague 2012. Solos include *At The Same Time* Cosa Gallery London 2009, *After Holiday 1986* Czech Centre Gallery Sofia *2009*, *Lucky Man* Caroline Wiseman London *2010*, *Artist of the Day 2013* Flowers Gallery London. Collections include British Museum.

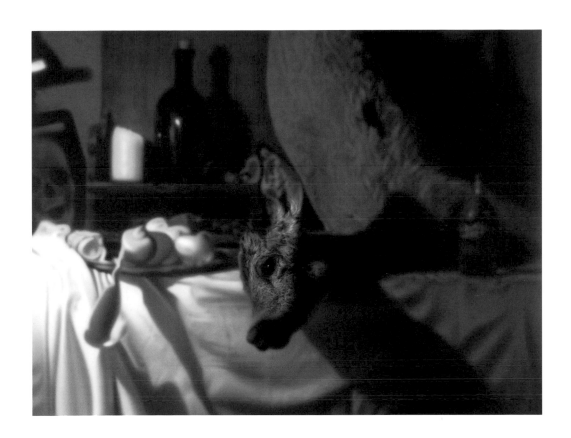

Hynek Martinec

John McSweeney

Legacy

2013
Oil and acrylic on MDF
98 x 122 cm

About eight years ago, my paintings shifted away from what I would describe as formal abstraction towards the depiction of the human figure. At first, I painted those closest to me, namely my son and daughter, looking at ways of combining digital images with paint. Then, I turned my attention to a modern phenomenon, that of isolation in a world increasingly given to so-called constant connectivity. I looked around, took photographs - something I have always done - and began making images. Some of these formed the starting point for a number of paintings. *Legacy* is one of them, a dystopian *Le Déjeuner sur l'herbe*, in which apples are consumed along with water that costs more than a phone call.

Biography

John McSweeney was born in London in 1952. After studying aeronautical engineering, he attended Camberwell College of Arts London 1980-5, later teaching there. His group exhibitions include those at Woodlands Art Gallery London 1995, Wolfson College Oxford 1991, Bruton Street Gallery London 1991.

Solo exhibitions include those at Angela Flowers Gallery London 1994, Sandra Higgins Gallery London 1989, Camden Arts Centre London 1989.

John McSweeney

Nicholas Middleton

Black Bloc

2013
Oil on panel
35.8 x 45.5 cm

The black bloc is not a coherent organisation or group, but a tactic to hinder the recognition of individuals and create the impression of solidarity during protests and direct action, primarily by the use of uniform clothing and face coverings. The practice of wearing near-identical black clothes and masks was initially developed by demonstrators from the anti-nuclear movement in Germany during the 1980s, and has spread globally. In the UK the black bloc was used most notably during the anti-cuts protest in March 2011. Through its paramilitary appearance the black bloc becomes, in essence, an autonomous mirror image of a state's riot police.

Biography

Born London in 1975, Nicholas Middleton studied at London Guildhall University 1993-4 and Winchester School of Art 1994-7. Shortlisted for BOC Emerging Artist Award 2002. Group exhibitions include *Mostyn Open 2011* Oriel Mostyn Llandudno, *Francis Bacon to Paula Rego* Abbot Hall Kendal 2012, *New East Anglian Painting* Ipswich Art School Gallery 2012. Exhibitor seven times *Summer Exhibition* Royal Academy of Arts London. Solo exhibitions include *Black & White Paintings* Arch Gallery London 2010, *Provisional Cities* The Crypt at St Marylebone London 2013. Exhibitor in the *John Moores* in 2004, 2006 (Visitors' Choice Prize) and 2010 (Prizewinner and Visitors' Choice Prize).

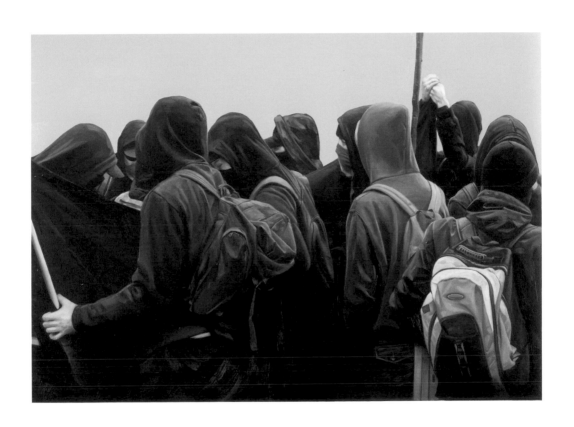

Nicholas Middleton

Reuben Murray

Sister, is that you?

2013
Oil on canvas
224 x 162.5 cm

My work consists of large-scale paintings which are developed over months and sometimes years. They explore the interface between art and medicine in the form of patients in varied medical settings. The portraits become emblems of pathology, as no specific injuries or diseases are mentioned. This evokes ambiguity as to the causes of that pathology. These portraits are a timeless glimpse of lives marked by suffering, loss, invincibility and resilience.

Each portrait asks us to be a companion willing to contemplate the mysterious fate of every individual life. Increasing advances in medical science, along with the pre-eminence of globalised technologies, challenge our idea of self and touch the very essence of our being. With religion and philosophy no longer able to offer a once powerful and compelling context, and their inability to give to suffering a credible meaning, a portrait can raise ethical and social questions of what it is to be human.

Sister, is that you? captures a moment of surprised recognition; it attempts a sensitive reflection of extreme perception and experience.

Biography

Reuben Murray was born in Manchester in 1964. He attended Manchester Academy of Fine Arts 1986-7, Chelsea School of Art London 1987-90, Slade School of Fine Art London 1991-3. Group exhibitions include *Presence: the human figure in painting and photography* Lana House London 1997, *Intimate Death* Klaus Engelhorn Gallery Vienna 2002, *Part 2* Lipane Putin Gallery Rome 2005, *Long Live Romance* Galleria Pack Milan 2005, *Bologna Art Fair* Lipane Putin Gallery Bologna 2006, *Drawings* Mia Gallery Verona 2007. Solos include *The Indelible Image* Slaughterhouse Gallery London 1993, *Pathologies of the Human Head* Exposition Espace Dordogne 1999.

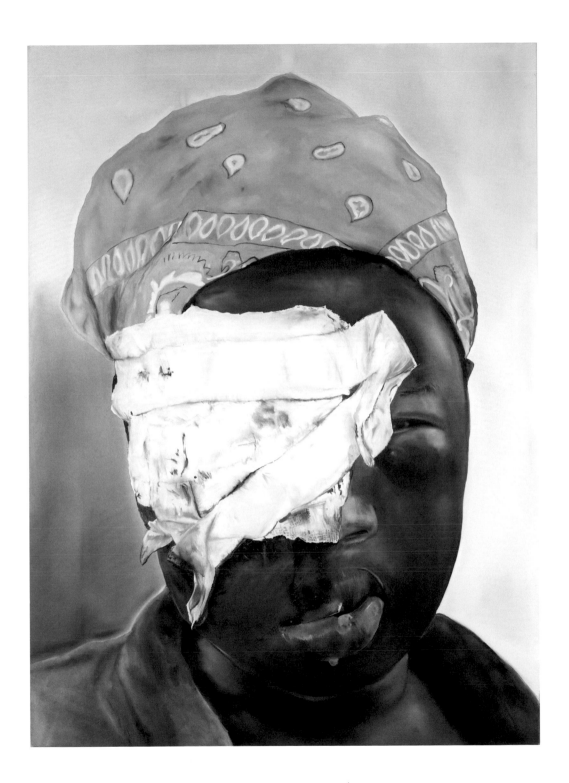

Reuben Murray

Tony Noble

Small Homes and Big Trees, Batley Carr

2013
Oil on panel
60 x 60 cm

This painting is one of a series I have been doing over the past 15 years, based on aspects of the urban landscape close to my studio in Batley Carr, West Yorkshire. I am interested in the contrasting scale of the trees and the houses, and the quality of the winter light, which creates a particular mood and atmosphere typical of this area. The scale of the trees signifies the power of nature and serves as a *memento mori*. I find the homeliness of the small houses quietly comforting. Modest in size, each one is someone's refuge, their castle, providing essential shelter. Though essentially the same, each has been personalised by its occupants and stamped with its own individual mark: a vase of flowers, a stained glass motif, blinds, a satellite dish, a net curtain. The crows' nests in the trees remind me that we are not the only homebuilders around here.

There are no figures in the painting as I think as soon as a figure enters, it creates a 'narrative noise', disturbing the peace and dominating the scene. Painting is for me a largely solitary, introspective activity and I enjoy the seclusion it offers.

Biography

Tony Noble was born in Batley in 1956, attending Loughborough College of Art 1976-9. After working as a primary teacher, he now paints full-time. Group exhibitions, all London, include *BP Portrait Award 2008, 2010-13* National Portrait Gallery (touring), *Sunday Times/RWS Watercolour Competition* Bankside Gallery 2009, Mall Galleries 2010, *London Royal Society of Portrait Painters* Mall Galleries 2010-13, *ING Discerning Eye* Mall Galleries 2010 (Winner of the Meynell Fenton Prize), 2011, 2013, *The Ruth Borchard Self-Portrait Competition* Kings Place Gallery 2011, *Royal Society of British Artists Exhibition* Mall Galleries 2011, *Lynn Painter-Stainers Prize* Mall Galleries 2013.

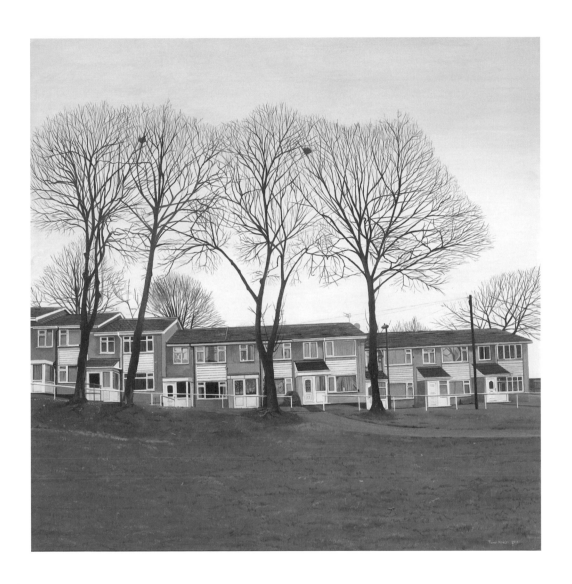

Tony Noble

David O'Malley

King of Infinite Space / Don't Let Life Pass You By

2013
Oil, acrylic and ink on canvas
29.8 x 21 cm

The paradox of the astronaut suit and the domestic setting creates a tension suggesting a plurality of narratives. A coalescence of implications obscures the balance between the realistic and the romantic. This juxtaposition of the normative, of the ordinary, and of the domestic environment, plays against the ultimate pioneering gesture embodied within the reference to space travel.

The painting remains a hymn to the infinite freedom of the imagination, despite the restraints of the mundane, real world. It acknowledges impending mid-life, and the first sobering realisation of mortality that this can bring, whilst including an assessment of achievements, or the lack thereof - the pangs of what might have been.

Biography

Born Ashton-under-Lyne, 1973, David O'Malley attended Blackpool and The Fylde College 1992-3, Teesside University 1994-7. Member Mas Civiles collective. Selected group exhibitions (London unless stated): *Life and Liberty* Westbourne Grove Gallery 2009, *Elements* Horsebridge Gallery Whitstable 2010, *Archways* To & For Gallery 2011, *Look To The Sky* NGC Sunderland 2012, *Metropolis* Lauderdale House 2013, *Cork St Open* The Gallery in Cork Street 2013, *20² Exhibition* Gallery TS1 Middlesbrough 2013, *Cluster 3* Trinity Buoy Wharf 2013, *6x6* Rochester Contemporary Art Center NY 2014, *Wish You Were Here* Magdalen Road Studios Oxford 2014. Solos: *Underpass* 540 Gallery 2006, *Nieuwe Detachementen* Logement Antwerp 2012.

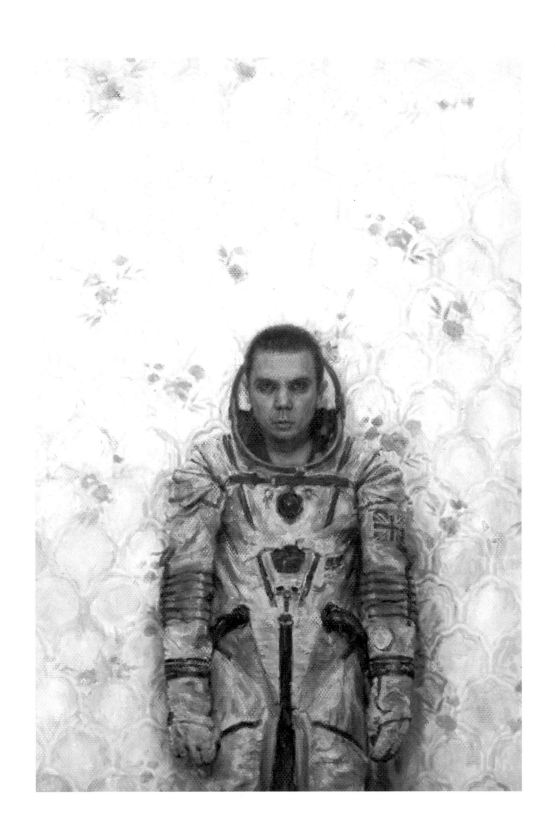

David O'Malley

Daniel Pettitt

Standard

2013
Acrylic on canvas
70 x 100 cm

My painting methods can be understood much like the process of collage; additive and subtractive forces regularly come into play. The works hover somewhere in between abstraction and figuration, a kind of para-painting that embraces plasticity and the malleability of materials. Second order imagery - cartoon text, advertising illustrations and motifs of other artists - are layered, pushed, pulled, reworked and repeated to introduce a disruptive aesthetic in the picture plane, making a kind of visual codex revealing and embellishing each omission and addition. These successive layers invite the viewer to situate themselves in relation to my painting and engage with my language. Each preceding painting informs that which follows, giving the working process a physical and conceptual plurality in which each work can function independently or as part of a series.

Biography

Daniel Pettitt was born in Brighton in 1986 and studied at Bath School of Art and Design 2005-8. Group shows include *Use & Mention* University of Greenwich London 2010, *Sagacity* Foreman's Smokehouse Gallery London 2011, *Parts & Labour* Camberwell Space London 2012, *Summer Saloon* Lion & Lamb London 2013, *Art Britannia* Madonna Building Miami USA 2013.

His first solo show, *Negative Capability*, was at Portsmouth Guildhall in January 2014.

Daniel Pettitt

Frank Pudney

People 69104

2013
Oil on board
201 x 122 cm

The *People* series, of which *People 69104* is the most recent work, depicts crowds in a moment of shared experience. Witnessing an event or force greater than ourselves, the insignificance of the individual is momentarily glimpsed. It is this perception of altered scale that these works seek to capture.

The viewer shifts focus between the microcosmic figures, the crowd as a mass of individuals, and the form created by the whole. The optical impact, with its kinetic force, engenders subjective and collective pattern associations. These tens of thousands of human beings - never touching - suggest the experiential quality of standing simultaneously in isolation and connection to others on both a local and global scale. In a world of digital, disembodied communication, *People 69104* reinstates the corporeal, organic nature of human experience and interrelatedness.

My fundamental interest is in creating work that evokes nature through abstract forms, in the lines between abstraction and representation. I am influenced by Paul Klee's concept of the artist's role as '...more than an improved camera...a creature on the earth and a creature within the whole, that is to say, a creature on a star among stars.'

(From *'Ways of Nature Study'* by Paul Klee, 1923)

Biography

Frank Pudney was born in Bedford in 1981 and studied at Norwich School of Art and Design 2000-3. His exhibitions include *Art of Imagination* Mall Galleries London 2007, *Umbrella* Zendai Museum of Modern Art Shanghai 2008, *Knapp Gallery Exhibition* Knapp Gallery London 2010, *Jerwood Drawing Prize 2011* Jerwood Space London (touring), *Art in Mind* Brick Lane Gallery London 2012, *Alter* Vegas Gallery London 2012, *Working on the Inside* Drawing Room London 2013, *Connecting Worlds* UBM Building London 2013/14.

Frank Pudney

Emma Puntis

Untitled, 2013

2013
Oil on linen
20.3 x 25.4 cm

My practice is rooted in a direct and intuitive response to my everyday surroundings through drawing and painting, predominantly in watercolour and acrylic. This work is part of a series of more labour intensive oil paintings based around a desire to transform a found photograph into an invested, painterly object.

Using traditional oil painting techniques I work over a period of several months on one or two paintings at a time. This allows me to construct the image gradually, creating slick, jewel-like surfaces where stronger, brighter colours glimmer and glow under a darker, more subdued palette. The slippery oil paint echoes the shifting emotional response to the inert image, and facilitates the continuous flux between figurative reality and painterly abstraction. A duvet cover becomes a veil of impressionist decoration, walls glow and a hotel room slips into an otherworldly, dis-inhabited stage set.

Biography

Emma Puntis was born in Birmingham in 1984. She studied at Chelsea College of Art and Design London 2003-6. Participating artist Triangle Artists' Workshop Triangle Arts Association New York 2008. Group exhibitions include: *Anticipation* David Roberts Art Foundation London 2007, *The Future Can Wait* Old Truman Brewery London 2007, *The Golden Record* Collective Gallery Edinburgh 2008, *Jerwood Contemporary Painters 2009* Jerwood Space London (touring), *Dough and Dynamite* White Space Gallery London 2010, *Stuart Bailes, Emma Puntis & Kate Warner* 53 Beck Road London 2013. Solo show *Wednesday's Child* was at Supplement Gallery London 2009.

Emma Puntis

Tim Renshaw

Nowhere

2013
Oil on aluminium
14 x 18 cm

Nowhere is 14cm x 18cm, the size of a standard notebook. As well as being the source of the painting's dimensions, the notebook's form is mimicked in the way this painting is divided symmetrically into two leaves and in the way thin vertical lines at the borders of the painting imply planes of layered pages. Drawing or writing in a notebook generally has an open-ended quality about it, where construction and design evolve without any clear sense of direction. Pages get turned, and traces of previous decisions appear. Like writing, the hand making these paintings moves from left to right, laying down its lines in a somewhat *ad hoc* fashion. When the surface is filled up, the work reaches its end.

There are, however, different types of fullness that dictate whether or not to begin again. In *Nowhere* it turns on the potential of this painting to deliver a tactile resonance that could bring the optical distance of its black horizon close to hand, so close in fact that it could be held and carried around in the pocket of a coat.

Biography

Tim Renshaw was born in Brighton in 1964. He studied at Leeds Polytechnic 1983-6 and Chelsea School of Art London 1989-90. He was an Abbey Rome Fellow in 2002 and a Cocheme Fellow in 2008. Solo exhibitions include *Images in the Vaguest Sense* V22 London 2008 and *House in the Shape of a Stretcher* Five Years London 2011.

He is part of the artist group Outside Architecture. Their recent projects include *One and One and One* CGP London 2012 and *One and One and One (part 2)* K3 Project Space Zurich 2012. Exhibited in *John Moores 23* 2004.

Tim Renshaw

Neal Rock

Inked Prosopon / 0813

2013
Silicone paint, Styrofoam and MDF
84 x 87 x 44 cm

Inked Prosopon belongs to a body of work that I have developed over several years, addressing histories of painting that have engaged with process and the act of making as constitutive of what an art work can mean or propose.

My hand brushes pigment into pools of silicone paint, imbedding colour into its surface. At an intermediate stage, during which the silicone is neither solid nor liquid, I sculpt the material over prosthetic-like armatures. Once the silicone skins solidify, they are removed from their supports, yet retain the shape of those prior structures. There follows a physical process of contorting and suspending the hollow, silicone forms.

Prosopon is an ancient Greek word conflating face and mask. It provides a narrative for my concern with painting's relationship to cosmetics. I have developed processes that reflect my interest in transparency and fixity, yet also touch upon makeup, opacity and mutability. Such qualities articulate an indirect address to a body, one that is veiled and transformed through cosmetic implants, filmic special effects and medical prosthetics, industries in which silicone is a material agent.

These concerns feed my practice, which possesses a performative sense, fusing surface and transformation, creating depth within an idea of the cosmetic.

Biography

Born in Port Talbot South Wales in 1976, Neal Rock attended the University of Gloucestershire 1996-9 and Central St Martins London 1999-2000. Currently undertaking a PhD at the RCA London. Group exhibitions include *Expander* Royal Academy of Arts London 2004, *Landscape Confection* Wexner Centre for the Arts Ohio/Contemporary Arts Museum Houston 2004-5, *Extreme Abstraction* Albright-Knox Buffalo NY 2005, *Jerwood Contemporary Painters 2007* Jerwood Space London. Solos include *Work from the Polari Range* FA Projects London 2003/Henry Urbach Architecture NY 2004, *Pingere Triptych* Grand Arts Kansas City USA 2006, *Fanestra & Other Works* The New Art Gallery Walsall 2009/Mihai Nicodim Los Angeles 2010.

Neal Rock

Conor Nial Rogers

88 Calories

2012
Acrylic on crisp packet
16.4 x 13 cm

My photorealistic depictions from everyday life emerge from an 'argument' between the illusionism of the image and the substrate of the paintings. When viewing paintings, the main focus is usually the representation created by the artist on a flat surface. Although my works have a familiar subject matter - the landscapes I experience every day - I intend that they go beyond the illusion of what I see to become both object and image at the same time. The success of my work lies not just in the quality of the representation, but in the moment the viewer's attention strays away from seeing the image and into the concrete reality of all the components of the painting. In combining image and object I endeavour to convey the intense reality of small moments of daily life. On the one hand my works are hyper-ordinary, but at the same time, I hope, extraordinary. The ordinary - the quotidian, or even abject - is turned into something precious, even jewel-like, through hours of time and labour.

Biography

Born in Sheffield in 1992, Conor Nial Rogers studied Creative Arts Practice at Sheffield Hallam University and lives and works in the city. Group exhibitions (all Sheffield) include *Clock Tower Exhibition* Clock Tower Gallery 2010, *You Are Here: A Sheffield Exhibition* Arundel Room The Millennium Galleries 2013, *Lost Property* (co-curator) Portland Works 2013, *You Are There* (co-curator) Creative Arts Development Space (CADS) 2013, *Interim Exhibition* SIA Gallery 2014, *Encounters* (co-curator) Arundel Gate Court Studios 2014.

Conor Nial Rogers

Karen Roulstone

Drift

2013
Oil glaze on wood panel
40 x 30 cm

I am interested in elusive, mysterious and abstract forms creating awkward visual encounters. Ideas unfold around mundane marks, fleeting thoughts, strange moments of stasis and the indeterminate.

Drift is part of a series of paintings which explore light, temporality and the possibility of ideas being illuminated through a decisive moment (*der Augenblick*); it is transient yet magically full of potential and significance. The painting presents a floating cloud of luminosity which is suggestive of both a movement across a translucent terrain and the revealing of another dimension.

Biography

Born in Toronto, Canada in 1963, Karen Roulstone studied at Exeter University 1983-6. Group exhibitions include *New Paintings* Tableau Vivant Toronto 1997, *4 Women, 9 Paintings* Tableau Vivant 2000, *TULCA Festival of Visual Art* Galway Ireland 2005, *Double Vision: A Dual Channel Video Festival* Herron School of Art Indianapolis 2009, *Afterimage, 8. Sommerfestival der Internationalen Kunst* (co-curated with Barbara Nicholls) Emerson Gallery Berlin 2013. Solo exhibitions include *Stasis* Larson Art Gallery University of Minnesota 2002, *Reconfiguring Absence* Robert Langen Gallery Waterloo Canada 2002, *Transient Luminous* Pavilion am, Milchhof e.V. Berlin 2012. Residency in Konstepidemin Gothenburg 2014 (forthcoming).

Karen Roulstone

Gideon Rubin

Three Girls

2012
Oil on canvas
148.3 x 198.5 cm

I think my paintings need time. They're definitely not the kind that shout at you from the other end of the room. In the past it used to be a cause of frustration, but then, with the years, I've discovered that the experience of looking at my work is a lot more subtle. When asked about my portraits I like to say that I would like them to be general and specific at the same time. It relates to the duality of the work and how I see memories. I enjoy when the viewer is provoked to play between past and present, space and non-space, description and abstraction...

Biography

Born Israel 1973, Gideon Rubin attended School of Visual Art NY 1996-9, Slade School of Fine Art London 2000-2. Exhibitions include *Family Traces* Israel Museum Jerusalem 2009, *Beijing Biennale* NAMOC Beijing 2010, *No New Thing Under the Sun* Royal Academy of Arts London 2010, *Lines Made By Walking* Haifa Museum of Art Israel 2011, *Facelook* Tel Aviv Museum of Art Israel 2011, *Measured Distance* Mackintosh Museum GSA 2012, *Künstlerkinder. Von Runge bis Richter, von Dix bis Picasso* Kunsthalle Emden Germany 2012. Solos include *Measured Distance* Rokeby London 2012, *Last Year's Man* Galerie Karsten Greve Paris 2013, *On the Road* Hosfelt Gallery SF 2013.

Gideon Rubin

Alli Sharma

Ingrid 2 (A Kind of Loving)

2012
Oil on canvas
50 x 40.5 cm

The idea that where you've come from should affect your life chances is viewed as deeply wrong by most people and, increasingly, social mobility is considered progressive. But does social mobility also come at a cost? There is an emotional concern and a sense of loss at the life left behind. A person may become a cultural omnivore, taking on board new identities, but equally could become culturally homeless, belonging to neither place.

Painting allows me to take an ambiguous glance back at my own past and the emotional investments we make. The north-east working class culture that I grew up in was very different from the one I now find myself in, and whilst I love my new life there is a price to pay, a loss incurred, people, places and things left behind.

Ingrid 2 is a portrait inspired by British social realism, in particular, the 1962 film *A Kind of Loving*. It is one in a series of paintings that spotlight the female characters, and not the angry young men who were the main focus at the time. The painting is stripped back and raw, revealing bold paint marks that transform the overlooked to evoke hidden histories.

Biography

Alli Sharma was born in South Shields in 1967 and attended Central Saint Martins 2002-7. Curated *Fade Away* Transition Gallery London/Gallery North Newcastle 2010/11. Recent group exhibitions include, 2013: *Duplicity* Transition Gallery London, *Painting Past Present - A Painter's Craft* Laing Art Gallery Newcastle, *I Love You Because* A-side B-side Gallery London, *Masque* Galerie d'YS Brussels, *Ornament* Transition Gallery at huntergather London, *The Dream Machine* Transition Gallery at Sluice Art Fair London, *Wintergarden* (curator) Sutton House London; 2014: *Stowaway* Weekend Los Angeles, (*detail*) H Project Space Bangkok, *Sex Shop* Folkestone Triennial 2014 (forthcoming).

Alli Sharma

Mark Siebert

Losers (Homerton High Street 3)

2013
Oil on found card
97 x 161 cm

Walking the streets of London, looking down at the pavement, amongst the fallen leaves and cigarette butts lay the discarded remains of lottery tickets, betting stubs and scratch cards. At times these seem almost ubiquitous. In various states of decomposition, they are a part of the streets, some torn, some ripped, others trampled.

Losers (Homerton High Street 3) is part of a series of paintings that records these tiny events, these tiny moments of life in the city. Found lying in the dirt by a broken pavement on the Homerton High Street in Hackney was a betting stub that represented a £20 loss. This stub, folded and discarded, is a hymn to hope, excitement, loss and instant gratification turned sour. This moment was captured on a phone camera and taken, with some cardboard packaging found in a bin nearby, to the studio, where the two were combined to make the painting.

Biography

Born Adelaide, Australia, 1980, Mark Seibert attended the South Australian School of Art 1998-2004. Group shows include *Other Worlds / Other News* Starkwhite Auckland NZ 2007; in 2008: *Plastic Theory* Peloton Sydney, *The Art of Correspondence* ACMI Melbourne, *Flipside* Substation Singapore; *Ready Village* Songzhuang Art Festival Beijing 2010, *Plus Art Projects* The Mayor's Parlour London 2012. Solos include *1 Million Dollars (V.1)* Beijing Studio Centre China 2010; in Adelaide: *Forever 27* Experimental Art Foundation 2009, *Poetry and Paydays* Greenaway Art Gallery 2011, *Losers* Greenaway Art Gallery 2013. Awards: Asialink Visual Arts Residency Award to Beijing China 2010, Florence Trust Residency London 2013.

Wimbledon College of Arts

Borrower name:
 Daniela Rodrigues Da Cunha
Card Number: *********275601

Items that you have borrowed

Title John Moores Painting Prize 2014 /
Barcode: 54224292
Due: 03 April 2018

Total items: 1
Account balance: £0.00
09/03/2018 16.14
Borrowed: 15
Overdue: 0
Reservations: 0
Ready for collection: 0

Mark Siebert

Mike Silva

Landscape

2013
Oil on linen
168 x 117 cm

I have always used the photograph as a model for painting. With this current landscape series, I have chosen worn out or degraded images.

In my previous work the content immediately steered the viewer into a particular narrative. These landscapes are part of an ongoing series in which the paintings inform one another and the outcome is determined by the materiality of the paint. The landscape is a familiar format but is utilised for my own purpose, which is to focus on the essence of painting.

Once an image is selected an outline is drawn onto the canvas. The painting process then starts from the top, working down to the bottom, 'wet in to wet'. I always make a smaller preparatory work which guides the larger painting. Much of the photographic information is edited out and simplified. This results in the mark-making being improvised, allowing the surface to have more of a physical presence, and making the process more evident - almost like 'thinking in paint'.

Biography

Born in 1970 in Sweden, Mike Silva attended Hastings College of Art 1988-9, Middlesex University London 1989-92, Royal College of Art London 1992-4. Group exhibitions include *The Triumph of Painting* (publication) Saatchi Gallery London 2006, *Collettiva* Galleria Enrico Astuni Pietrasante 2006, *Super Natural* Charlie Dutton Gallery London 2010, *12 from No 10* Whitechapel Gallery London 2012, *Unknown Sitter* Lion & Lamb London 2013, *Dan Coombs, Mike Silva. Neal Tait.* Charlie Dutton Gallery 2013. Solo shows include Wilkinson Gallery London 2002, 2004, Galleria Enrico Astuni 2007, Charlie Dutton Gallery 2011, 2012. Collections include British Council, Government Art Collection, Saatchi Collection.

Mike Silva

Rebecca Sitar

Under the Tree

2013
Oil on panel
25.4 x 31 cm

My work has been referred to as hermetic, in that it doesn't occupy a single orthodox position, figurative or purely abstract. *Under the Tree* is from a recent series of paintings that substitutes a figure for a single object of contemplation, previously seen as a leitmotif in my work.

The source of the image was a 1914 photograph by Stéphane Passet of an eastern sadhu covered in cremated ash near the river Ganges. The photograph was commissioned by the philanthropist Albert Kahn.

I have used a two-tone application to create a single unified space; sky, tree and man are depicted as one. The arrested fluidity of the paint is intended to mirror the subject's experiential quest to attain a sense of calm.

Biography

Born 1969, Rebecca Sitar attended Winchester School of Art 1988-91, Manchester Metropolitan University 1991-2. Exhibitions include *Slow Burn: Meaning & Vision...* Mead Gallery Warwick 1998 (touring), *Surface Presence* Sarah Myerscough London 2000, *Beginnings* Whitworth Art Gallery Manchester 2000, *Beyond the Endgame...* Manchester Art Gallery 2003, *Abstractions...* Campden Gallery Chipping Campden 2008, *Sculpture is a vulture...* Malgras/Naudet Manchester 2011, *Wendy Anderson, Denise de Cordova, James Fisher, Rebecca Sitar* Emma Hill Fine Art Eagle Gallery (EH) London 2013, *Oriel Davies Open 2014* Oriel Davies Newtown. Solos include *Ritual* EH 2001, *Hinterland* EH 2004, *Present & Elsewhere* Galerija Karas Zagreb/EH 2006-/7 (touring).

Rebecca Sitar

Ian St. John

Fallen Matter

2013
Oil on board
34 x 24.8 cm

My work explores the paradoxical relationship between waste and aesthetics, offering commentary on consumer culture with a particular focus on the 1970s and 80s. Aesthetically I find myself drawn to and inspired by the formal qualities of the imagery; the richness of the colours and tone in everyday advertisements and photographs generated in a pre-digital age. I find the textures of *Fallen Matter* alluring; the shiny, harsh chrome is contrasted against the softness of the synthetic velour and canvas seat-covers.

Yet the politics of waste are repellent. Global corporations in this period celebrated the built-in obsolescence of objects and products in the name of luxury and abundance; discarded airline seats in this 1970s advertisement served as a metonym for technological progress, material wealth and comfort. Today, thanks to our ecologically-driven, critical counterculture, we read the image differently. The airline seats take on the aura of decaying carcases: the American term suggested by this scene, most appropriately, is 'boneyard'. I draw attention to the disposability of our lives and our notions of value. But perversely, in the process of image selection and painting, I perform an act of distillation and refinement.

Biography

Ian St. John was born in Exeter, Devon in 1971. He studied at Falmouth College of Arts, Cornwall 1995-8 (Fine Art) and Newcastle University, Newcastle upon Tyne 2003-5 (MA Fine Art). His exhibitions include *NOA* Minerva Theatre Chichester 2011 and *The Threadneedle Prize* Mall Galleries London 2012.

Ian St. John

Lexi Strauss

Tupperware Party

2013
Acrylic on paper
42 x 29 cm

My subjects often appear clownish, displaying both a rigid facade and a vulnerable persona. Men are genuinely able to breastfeed naturally; perhaps this tender, yet somehow inadequate father personifies general human short-fallings in parenting proceeding generations.

Narratives arising from interviews and my imagination are integral to the work. This painting indirectly illustrates *The Twelve Apostles as Babies* and *The Vulnerable Party* - two specious, fluid narratives that weave into and out of the imagery. They explore our complex relationships with belief systems.

The Vulnerable Party relates the search for a supremely divine clown leader - humane and genuinely open, with strengths and weaknesses exposed. However, since this ideology necessitates individuation, it's incompatible with the idea of a 'political party'. Thus, the party is reduced to a one-person campaign, without cabinet or voters.

The Twelve Apostles tells of the infant apostles' arrival for the second coming, but without Christ. Dressing up as Gandhi, Johnny Rotten and others, they learn the good deeds of those who came both after and before them. Eventually, through their various careers, they manage to spread their good news, individually.

Biography

Born in Nottingham in 1977, Lexi Strauss attended Hereford College of Arts 2009-11 and the Royal College of Art (RCA) London 2012-14 (Winner: Winsor & Newton/RCA scholarship and Elmley Foundation Bursary). She is also a parent. Group exhibitions include *Candid Arts* Universität der Künste Berlin 2011, *Painting Nov* Henry Moore Gallery RCA 2013, *Notes to Self* Dyson Gallery RCA 2013, *React* Dilston Grove London 2013, *Anthology* Charlie Smith London 2013. Shortlisted *New Contemporaries* 2013. Solo exhibitions *Empty Chairs* Institute of Art and Ideas (Hay Festival) Hay on Wye 2013; MAC Birmingham 2015 (forthcoming).

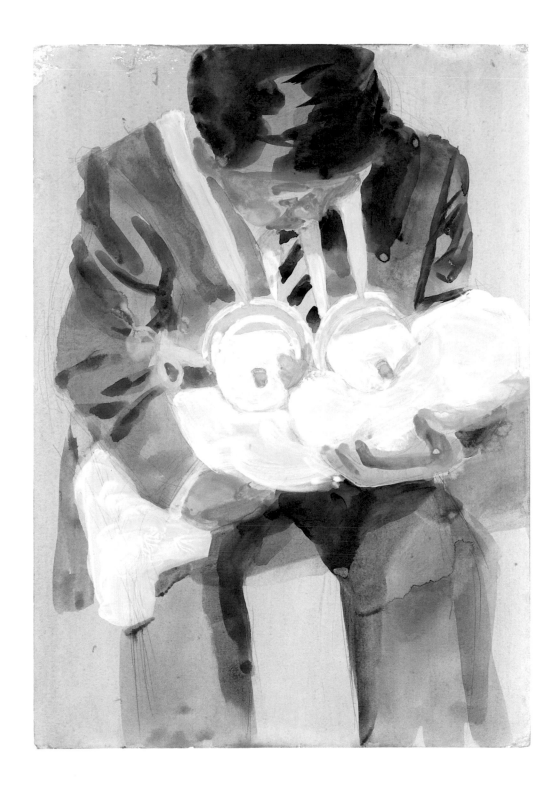

Lexi Strauss

Trevor Sutton

Christow

2013
Oil on paper on board
94 x 63.5 cm

My work is fed by an irrational take on life, a life that gets re-ordered within abstraction by employing the restraints of a ritualistic and organised process, embedded within the sensual reality of oil paint.

This painting's title, *Christow*, takes its name from a village in Devon in the Dartmoor National Park. I have a studio there, where I work, listen to a now rarely-played collection of vinyl and spend time reconnecting more closely with nature. I see this location as a retreat from London, where I normally live and work.

Christow is like a visual musical score; its colour has a quiet hum which I associate with the place. It is more akin to a state of mind than a description.

Biography

Trevor Sutton, born Romford 1948, attended Hornsey College of Art 1967-71, lectured Chelsea College of Art & Design 1973-2000. Exhibitions include *Constructed* Sainsbury Centre Norwich 2008, *Take Two* Noborimachi Space of Art Hiroshima 2010, *HA HA WHAT DOES THIS REPRESENT?* Standpoint Gallery London 2012, *New Possibilities: Abstract Paintings from the '70s* Piper Gallery London 2012, *Wanderer's Field* Eagle Gallery London 2013. Solos include *Coloured Time* Galerie Sho Tokyo 2007, *Paintings* Another Function Gallery Tokyo 2010, *Paradise Circus* Flowers Central London 2010, *Rose Paintings* Kunstgarten Graz Austria (Artist-in-Residence) 2012, *Interior Landscape* allerArt Bludenz Austria 2013. In *John Moores* 1980 (Prizewinner), 1982, 1993, 2012.

Trevor Sutton

Trisant

New Logo (White-Red): Bear Stearns #15

2013
Acrylic 2-pack enamel on Dibond board
100 x 125 cm

The work draws on the accumulation of advertising imagery and branding that we encounter on a daily basis, yet successive shifts and alterations create hybrid forms from the original points of reference.

Corporate logos are broken apart, abstracted, mashed up and reconfigured into new forms. Bear Stearns was a large-scale casualty of the global financial crisis of 2007, subsequently sold to JP Morgan Chase which later dropped the company name.

A key aspect of the piece is the physical re-arrangement of the painted panels – shifted, rotated, linked and spaced apart. There is a play between each panel as a distinct element and a dialogue between the parts within the group. The elements of flux and play in the multi-panel paintings are influenced by the shifting components of 15-square puzzle games and by the repetitive patterns of decorative tiles.

The work draws on the accumulation of advertising imagery and branding that we encounter on a daily basis, yet successive shifts and alterations create hybrid forms from the original points of reference.

Biography

Born Cardiff in 1969, Trisant studied at Birmingham Institute of Art and Design 1988-91 and the Royal Academy Schools London 1991-4. He is Senior Lecturer in Computer Games Art at Anglia Ruskin University Cambridge. Group exhibitions include *Intervention* Fieldgate Gallery London 2007, *Saxon* Schwartz Gallery London 2009, *Dawnbreakers* John Hansard Gallery Southampton 2010, *The Thing is the Thing* ASC Gallery London 2011, *Bankrupt Revellers and the Crash* (with Rachel Levitas) Maison Bertaux London 2012, *Six Degrees of Separation* Wimbledon Space London 2013, *This-Here-Now* no format London 2013. Solos include *Product Range Repeat* (*Deptford X 2010* Award) London 2010.

Trisant

Covadonga Valdés

Homeland

2013
Oil on aluminium
50 x 60 cm

For the last ten years I have been working with the landscapes of northern Spain, England, Italy and Swedish Lapland. My aim has been to juxtapose my experiences of these very different landscapes into a new arrangement, drawing together subjects from different places and countries to construct a believable composition with the kind of tensions and moods that reflect our time.

A part of this journey involved looking for a grounded painting. My quest for the roots of the image has revolved around the intangibility that is created from reflection, light and shadow whereby the painting grows into an almost topographic image that is concerned with detail. In doing so it encompasses not only the representation of relief and natural and artificial features but also the histories and the cultures that inhabit that new landscape.

While it is not intended that my paintings should document any particular place or country, they represent instead the collective familiarity of European landscapes.

Biography

Born Astrurias, Spain, 1966, Covadonga Valdés attended Chelsea College of Art 1988-92 and the Slade School of Fine Art London 1992-4. Group exhibitions include *Turps Banana* Galleria Marabini Bologna 2009, *The Chapter of the Forest* The Collection/Usher Gallery Lincoln 2011, *Polemically Small* Torrance Art Museum/Garboushian Gallery Los Angeles and Charlie Smith London 2011, *Ex Roma* APT Gallery London 2012, *I Don't Know How a Rock Feels* British School at Rome Italy 2012, *Crash Open Salon* Charlie Dutton Gallery London 2013. Solo exhibitions include *Recent Paintings* Pump House Gallery London 1999, *Hideaway* Contemporary Art Projects London 2007. Exhibited *John Moores* 2004, 2006.

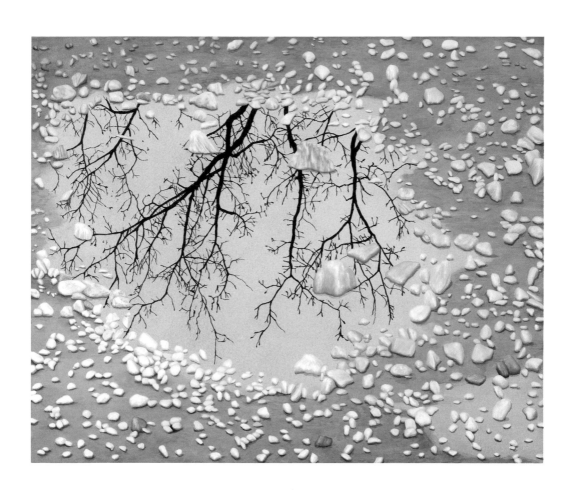

Covadonga Valdés

Roxy Walsh

Tunnel of Love

2012
Watercolour on gesso panel
25.6 x 19.6 cm

'In his extreme youth Stoner had thought of love as an absolute state of being to which, if one were lucky, one might find access; in his maturity he had decided it was the heaven of a false religion, toward which one ought to gaze with an amused disbelief, a gently familiar contempt, and an embarrassed nostalgia. Now in his middle age he began to know that it was neither a state of grace nor an illusion; he saw it as a human act of becoming, a condition that was invented and modified moment by moment and day by day, by the will and the intelligence and the heart.' *

I make paintings in watercolour on paper, panel, linen and on walls. I am interested in body language within the paintings and in continuities between language and image. My preoccupation is with the effects of one's physical encounter with work - from the slow, smooth, surface of gesso and the pace of staining and marking through to the particular kinds of attention that people pay in galleries and museums, churches and cells. I also collaborate with sculptor Sally Underwood, making large-scale installations in which sculpture and painting are in conversation with each other.

(*From John Williams Stoner, '*Vintage Classics*', 2012, p 201)

Biography

Born County Tyrone, 1964, Roxy Walsh attended Manchester Polytechnic 1982-6. Senior Lecturer Fine Art, Goldsmiths. Exhibitions include *INFALLIBLE, In Search of the Real George Eliot* (exhibitor/curator) APT Gallery London (touring) 2003/5, and solos *Felix Culpa* Reed Gallery Cincinnati (touring) 2006/7, *Second Sex* Galerie Peter Zimmermann Mannheim 2011, *IGLOO* (with Sally Underwood) Fishmarket at... Northampton/Globe Gallery Newcastle 2012, *The Lady Watercolourist* The MAC Belfast 2012, *ArtKapsule Presents... Roxy Walsh at Koleksiyon* ArtKapsule London 2013, *Body Language* Galerie Peter Zimmermann 2013, *Dependent Rational Animals* (with SU) Towner Eastbourne 2013, *Two Tongues Tied* Leyden Gallery London 2014. Chandelier Projects London (with SU) 2015 (forthcoming).

Roxy Walsh

Carlos Zuniga

Woman on the Grass

2013
Acrylic on canvas
107.8 x 79.5 cm

Woman on the Grass is an image that challenges the viewer's perception as a result of its construction from three colours: Red, Green and Blue (the RGB colour model). At a certain distance the optical perception of colour allows the viewer to see the whole picture, but as we approach the image is deconstructed; colours change, or rather, are presented as pure material or paint. Between the viewer and the image, the perception of light becomes a critical bridge to painting.

The research I conduct in my paintings finds its aesthetic references in the technical aspects of Impressionism and photography. The original image for *Woman on the Grass* was captured via iPhone on Hampstead Heath, London, in the summer of 2013. The classic and romantic composition illuminates my systematisation of the pictorial gesture in order to capture and challenge the eye of the observer, and where possible, to alter their modes of thinking.

Biography

Born in 1972 in Chile, Carlos Zuniga lives and works in London. He studied at the Andrés Bello National University (Architecture) 1991-2, Professional Institute of Providencia (Design) 1993-6 and University of Chile (Fine Art) 2003-6. Recipient: Grant Fondart, Chilean Ministry of Culture, 2007. Exhibitions include *Next* (two-person) Balmaceda Gallery Santiago 2007, *Bicentenary Young Artist Exhibition* (2nd prize) Visual Art Museum Santiago 2007, *Full Image* Santiago de Queretaro Museum Queretaro Mexico 2008, *Replica* Azerty Gallery Paris 2010, and solos *Detained in Apnea* Florencia Loewenthal Santiago 2008, *Beginning of the Aura* AMS Marlborough Gallery Santiago 2010, *Imperial Poem* Edel Assanti London 2010.

Carlos Zuniga

Index of artists

National Museums Liverpool cannot be held responsible for the content of external websites

Phil Ashcroft
Lewisham Arthouse
140 Lewisham Way
London
SE14 6PD
www.philashcroft.com

Jo Berry
www.joberry.me.uk

Jane Bustin
www.janebustin.com

James Byrne
Birmingham Art Space Studios
Unit 301
The Telson Centre
Thomas Street
Aston
Birmingham
B64 TN
www.jamesbyrneart.com

Wayne Clough
www.waynecloughart.com

Paul Collinson
www.englandsfavouritelandscape.co.uk

Christopher Cook
Art First
21 Eastcastle Street
London
W1W 8DD
info@artfirst.co.uk

David Dawson
Marlborough Fine Art
6 Albermarle Street
London
W1S 4BY
mfa@marlboroughfineart.com

Robin Dixon
www.robin-dixon.co.uk

Fiona Eastwood
www.fionaeastwood.com

Robert Fawcett
www.robertfawcett.co.uk
robertfawcett.art@gmail.com

Tom Hackney
www.tomhackney.com

Susie Hamilton
www.susiehamilton.co.uk
www.paulstolper.com

Rae Hicks
cargocollective.com/raehicks
raehicks@rocketmail.com

Charlotte Hopkins Hall
www.charlottehopkinshall.com

Barbara Howey
www.barbara-howey.co.uk

Thomas Hylander
www.davidrisleygallery.com
info@davidrisleygallery.com

Andy Jackson
ASC Studios
Worsley Bridge Road
London
SE26 5AZ
andyjackson.org.uk

Nicholas Kulkarni
Studio 48
ACME Studios
165 Childers Street
London
SE8 5JR
www.nicholaskulkarni.com
mail@nicholaskulkarni.com

Rachel Levitas
www.rachellevitas.com

Juliette Losq
www.losq.co.uk

Mackie
www.mackie-art.com

Hynek Martinec
ASC Studio
Stockwell Road
London
SW9 9SP
www.hynekmartinec.com
hynek.martinec@hotmail.com

John McSweeney
141 Acton Lane
London
NW10 7PB
www.johnmcsweeney.com

Nicholas Middleton
www.nicholasmiddleton.co.uk
info@nicholasmiddleton.co.uk

Reuben Murray
44 Bonner Road Studios
Bethnal Green
London
E2 9HJ
reubenjsmurray@gmail.com

Tony Noble
Redbrick Studio
218 Bradford Road
Batley
West Yorkshire
WF17 6JF
www.tonynoble-artist.com

David O'Malley
www.davidomalley.net

Mandy Payne
Tarpey Gallery
77 High Street
Castle Donington
DE74 2PQ
www.mandypayneart.co.uk

Daniel Pettitt
Sara Lane Studios
60 Stanway Street
London
N1 6RE
www.danielpettitt.co.uk

Frank Pudney
www.frankpudney.com

Emma Puntis
Acme Studios
Studio 12
44 Copperfield Road
London
E3 4RR
emmapuntis.com

Alessandro Raho
Alison Jacques Gallery
16-18 Berners Street
London W1T 3LN
info@alisonjacquesgallery.com

Tim Renshaw
Department of Art
University of Reading
1 Earley Gate
Whiteknights
Reading
RG6 6AH
www.outsidearchitecture.org

Neal Rock
www.nealrock.com

Conor Nial Rogers
conorrogers1992@hotmail.co.uk

Karen Roulstone
www.karenroulstone.com
karenroulstone@gmail.com

Gideon Rubin
Rokeby
16 Rosebery Avenue
London
EC1R 4TD
www.rokebygallery.com

Alli Sharma
Transition Gallery
Unit 25a Regent Studios
12 Andrews Road
London
E8 4QN
www.allisharma.com
www.transitiongallery.co.uk

Mark Siebert
www.marksiebert.org
mark.d.siebert@gmail.com

Mike Silva
Occupation Studios
7-10 Occupation Road
London
SE17 3BE
mikesilva70@gmail.com

Rebecca Sitar
www.rebeccasitar.co.uk
www.emmahilleagle.com

Ian St. John
istjsmi@hotmail.com

Lexi Strauss
www.lexistrauss.com

Trevor Sutton
www.trevorsutton.com

Trisant
www.trisant.com
trisant333@gmail.com

Covadonga Valdés
www.covadongavaldes.com
covadongavaldes@icloud.com

Roxy Walsh
www.roxywalsh.com

Rose Wylie
30 The Street
Newnham
Sittingbourne
Kent
ME9 OLQ
jari@uniongallery.com
rosewylie8@btinternet.com

Carlos Zuniga
Studio
181-183 Bow Road
London
E3 2SJ
www.carloszuniga.org
carlos@carloszuniga.org

John Moores
Painting Prize
China 2014

The jury

Lewis Biggs
Non-voting Chair

Zhang Enli
Artist

Lisa Milroy
Artist

Mali Morris
Artist

Amikam Toren
Artist

Wang Xingwei
Artist

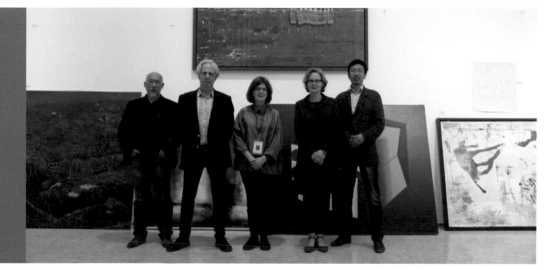

Zhang Enli, Amikam Toren, Mali Morris, Lisa Milroy, Wang Xingwei

Preface

By Wang DaWei

Dean, College of Fine Arts, Shanghai University
Vice Chairman, Shanghai Artists Association

To date, the *John Moores Painting Prize China* has been held three times. The prize, established in England in 1957, has a strong reputation around the world, and the prize for China has already become influential among art professionals here. In 2010, for the first Chinese prize, there were 1,100 competitors coming from 11 provinces. By 2012, 2,200 submissions came from 26 provinces. The statistics for this year's prize are even more spectacular, with 3,010 artists from 34 provinces submitting work. The increase in the number of competing artists by a thousand, year on year, is a clear indication of the attraction and impact of the prize.

As sponsoring organiser of the China Prize, the College of Fine Arts at Shanghai University has the following aims: first, to promote talent in Chinese contemporary painting; and second, to bring greater global recognition to Chinese contemporary painting. Our involvement in the biennial competition over the past five years has made some important progress towards realising these aims.

Some useful and enlightening insights can be gained from better understanding the selection system of the *John Moores Painting Prize China*, and how the competition operates.

The selection process of the Chinese competition involves jurors who are internationally recognised artists from China and the UK. The route towards deciding on the prizewinners begins with the judges from the two countries coming together to discuss the merits of each work in terms of both form and content. They ultimately arrive at their conclusions through continued debate and discussion, finally with the actual shortlisted works, here in Shanghai. This enables not only a full evaluation of the paintings, but also, through selection and the awarding of the five prizes, has the effect of bringing the highest commendation to the artists and the chosen prizewinners. As a result, the profiles of the previous prizewinners have successfully been raised in painting circles both in China and the UK. They have become early pioneers of the prize, and the competition continues to shoulder its responsibility for promoting new artists. Indeed, the 2014 exhibition at the Shanghai Himalayas Art Museum has been supplemented with a documentary section which summarises and reviews the previous two competitions in 2010 and

2012. It shows vividly the positive impact of the prize on the careers and reputations of the winners.

The Chinese competition does not have a monetary prize. Rather, it extends to the winners the prospect of international exchange and study. The partner organisation in England, Liverpool John Moores University, offers a residency for the winners to study, create new paintings and hold an exhibition in the UK. The university creates opportunities for the winners to communicate and exchange ideas with first-rate artists and art institutions, building a bridge of international exchange across which Chinese contemporary art can enter the wider world.

The range of expertise and knowledge that the jurors bring to the *John Moores Painting Prize China* is vital to ensure a variety and breadth in the selection of work as well as in those finally judged to be of the greatest quality. The *style* of the winning painting should not be the criteria of success; rather, its *quality*. An imbalance of experts in one particular style may create bias towards their own preferences. The careful selection of judges is therefore a priority, both to

promote the academic standing of the College of Fine Arts and for the successful outcome of the competition. The rich experience and keen academic insights of the British curator, Lewis Biggs, in choosing judges offers valuable learning opportunities.

It is noted with regret that ink-wash painting, one of the most important forms of Chinese contemporary painting, has not accounted for a commensurate proportion of submitted entries. Furthermore, few of the submitted ink-wash paintings have been awarded prizes. In this respect, the competition does not currently provide a fully accurate representation of Chinese contemporary painting. We need to reflect further on this in the selection of judges for future years' competitions.

In addition to supporting the *John Moores Painting Prize China*, the College of Fine Arts at Shanghai University has co-operated with the International Association of Art Critics (UK branch) and, in 2012, with Liverpool John Moores University, in founding an award for the critical reviewing of art exhibitions. The Art Exhibition Review Award China has been established with the aim of advancing the

ecology for contemporary art in China and the UK, through the encouragement of critical and scholarly reviewing.
The principles of selection for this award are borrowed from the *John Moores Painting Prize* - that is, it selects winners anonymously, based on their submitted writing. The reward is opportunity rather than money. The *John Moores Painting Prize* and the Art Exhibition Review Award are designed to work together to foster the healthy development of contemporary art.

It is true that great things may be accomplished through collective effort. Time moves on, and the *John Moores Painting Prize China* has been held successfully on three occasions. We will continue to maintain the overriding principles of professionalism, and transparent and fair decision making. Even more vital to the healthy development of the prize is to continue to gather world-wide attention, to gain the understanding and appreciation of decision makers, and to generate interest from society as a whole. We will strive to develop the prize, so it can be rightfully seen as the premier platform for Chinese contemporary art; supporting artistic talent and promoting the best of Chinese contemporary painting throughout the world.

Preface two

By Lewis Biggs OBE FLJMU
Trustee, John Moores Liverpool Exhibition Trust
Chair of the Jurors, John Moores Painting Prize China 2014

This is the third edition of the *John Moores Painting Prize China*, and, after their initial showing at the Shanghai Himalayas Art Museum (April-May 2014), the five prizewinning paintings published here will be exhibited alongside the paintings selected for the *John Moores Painting Prize 2014* exhibition at the Walker Art Gallery, as a part of the programme for this year's Liverpool Biennial. Dean Wang DaWei's preface gives evidence for the continually increasing profile of the competition in China, and I'm convinced that this year it has reached an even higher level of quality than its predecessors.

The diversity of genres and media submitted is remarkably consistent across the years and between the two cultures. The business of the jurors is to find the best examples of each genre, whether still life, landscape, surrealist, portraiture, abstraction, or urban landscape, to name but a few. The relative scarcity of ink painting submitted in China (as noted by Wang DaWei) is unfortunate, since such rich skill is to be found there. Perhaps it's even harder for ink painters than for oil painters schooled in social realism to identify their aims with those of 'international' contemporary artists. But I believe the proportion of 'conceptual'

paintings submitted in China has grown since 2010, and I'd say that all five of the prizewinning works this year can be seen as instruments for thinking, challenging or questioning our experience.

I was a juror for the *John Moores Painting Prize* in 1991, and was on the first two Chinese competition juries. This year it has been my honour and pleasure to chair the selection process in China as a non-voting jury member. I have had all the delight of seeing the artworks and listening to the jurors' discussions, without the responsibility for deciding which paintings should finally be exhibited or shortlisted for prizes.

I want to thank the five jurors most sincerely for their painstaking work in scrutinising more than 3,000 submissions, and especially for being willing to enter into heartfelt discussions in order to arrive at a deeper appreciation of the paintings under review. Their passion and experience are the guarantee that only the highest quality paintings are selected for exhibition and commendation to the public and their peers.

On behalf of Joanna Laing, Chair, and the other Trustees of the John Moores Liverpool Exhibition Trust, I would like to extend our thanks to some of the many people who have made the *John Moores Painting Prize China* possible in 2014.

Our Academic Partner, Liverpool John Moores University, has become increasingly involved in the cultural exchange constituted by the competitions in both countries since 2010, and the university is now a very significant supporter. Our thanks go to Professor Nigel Weatherill, the Vice Chancellor, for his personal commitment to this exchange.

We thank Wong Shun Kit, Director, Shanghai Himalayas Art Museum, for his welcome to our mission and our project; and Sandra Penketh, Director of Art Galleries at National Museums Liverpool, and all the staff of the Walker Art Gallery, who welcome the 'China section' of the *John Moores Painting Prize* to Liverpool and facilitate the exchange of prizewinning paintings with Shanghai.

I would also like to express the enormous gratitude felt by all the Trustees towards Wang DaWei, Dean of the College of Fine Arts at Shanghai University, who has

again taken responsibility for the complex and demanding organisation of the prize and exhibition in China; this has been carried out with such panache and efficiency by Professor Lingmin from his Faculty.

Finally, but most significantly, this is the first time that the *John Moores Painting Prize China* has received corporate sponsorship, and I would like to extend our great thanks to Bob Grace, CEO China, and all of his team at Jaguar Land Rover, for their crucial interest and support in this year's competition, as well as their indication of support for 2016 and 2018. With the deep connections and many exchanges between Shanghai and Liverpool exemplified both by the *John Moores Painting Prize* and by Jaguar Land Rover, we believe our partnership in praise of quality is made at a global, and maybe even a celestial, level. Long may it continue.

**First prizewinner
Zheng Haozhong**

**Prizewinners
Liu Gang
Liu Shaojun
Zhong Yuexing
Zhu Xiaocong**

郑皓中
Zheng Haozhong

邱晨
Qiu Chen

2013
Oil painting
200 x 150 cm

A person sits quietly, both partial and complete. I spent much time with my model, until I was exhausted. I absorbed myself in the drawing. I used the rhythms of brushwork to reflect the compositional divisions of the whole. I enjoyed the whole nonsense and humour of the process.

Biography

Zheng Haozhong was born in 1985.
He studied in the Oil Painting Department
at the Central Academy of Fine Arts,
Beijing (Bachelor's Degree 2008).
A solo exhibition *'Untitled' Outcome to
Painting* was at Ya Du Art Gallery
Shandong 2013.

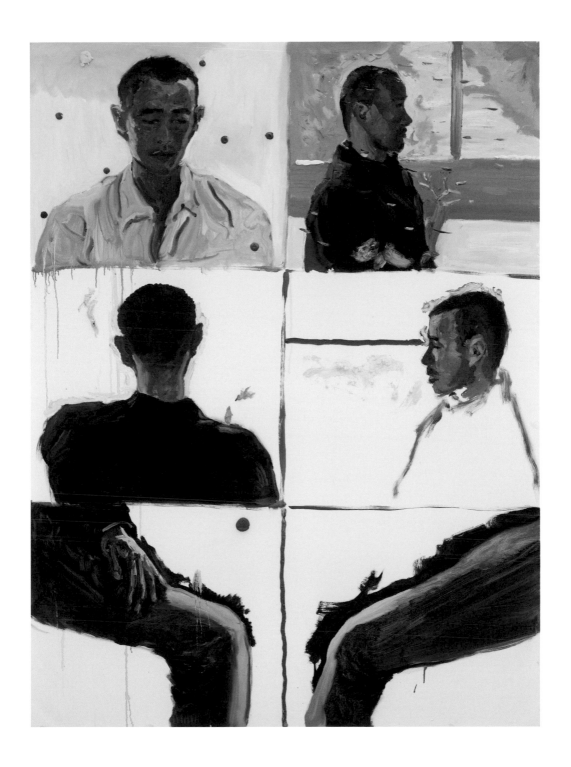

Zheng Haozhong

刘刚

Liu Gang

我看到了你的眼

I Saw Your Eyes

2013
Oil painting
190 x 130 cm

Seeing a stray dog is too common a thing. But this time, I suddenly felt that its eyes looked similar to most people's in today's society. On this dog's face I found a human-like expression. I was astonished and thought to myself, "What is the difference between its suffering and ours?"

Biography

Liu Gang was born in 1979. He undertook studies in the Oil Painting Department at LuXun Academy of Fine Arts (Postgraduate Degree 2008). Included in the recent group exhibition *Scenery* TART Art Group Shanghai.

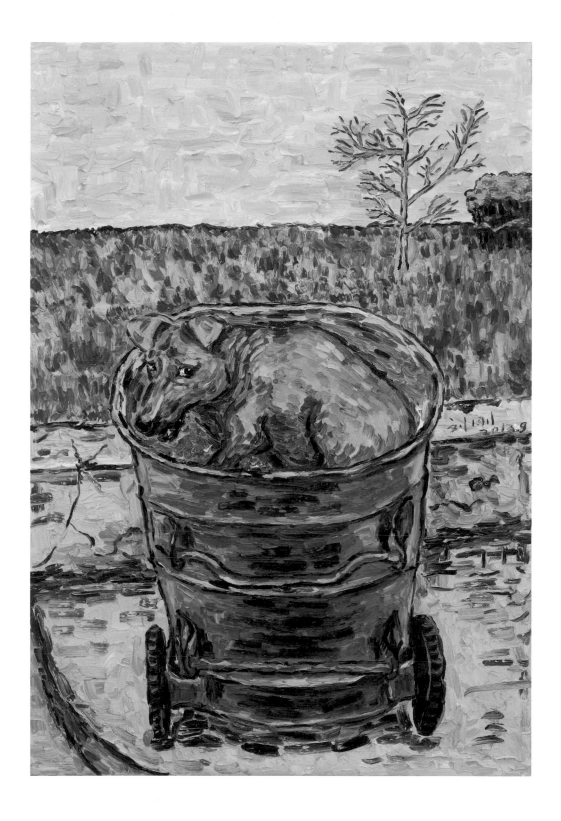

Liu Gang

刘绍隽

Liu Shaojun

穿在钢管上的五个五角星

Five-Pointed Star Across the Steel Tube

2010
Acrylic on canvas
150 x 120 cm

This work is a smaller piece from a series I produced in 2010. In my work, five-pointed stars are the symbols for men, since they represent how sometimes men can be hurt. They are also a symbol of the Pope, and, ultimately, symbolic of certain ideals.

Biography

Liu Shaojun was born in 1964.

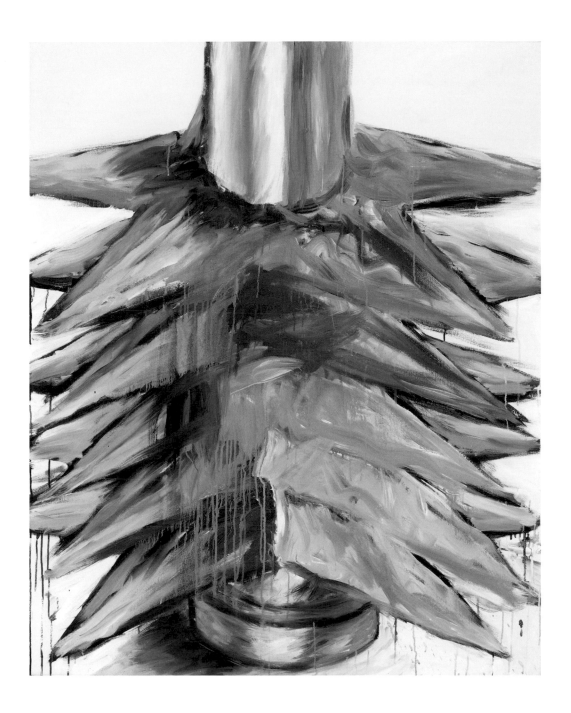

Liu Shaojun

钟乐星
Zhong Yuexing

角色的寓言系列五
The Role of Fable Series 5

2011
Oil on canvas
114 x 134 cm

Although I have a daytime job, I always continue to paint when I can. This work is from my favourite series of paintings.

Biography

Zhong Yuexing was born in 1984.
He studied in the Fine Arts Academy
Oil Painting Department at South-Central
University for Nationalities (Bachelor's
Degree 2009).

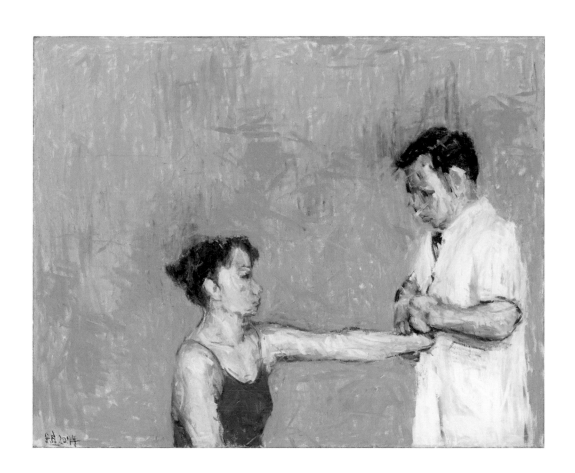

Zhong Yuexing

朱晓聪
Zhu Xiaocong

我不知道
I Don't Know

2013
Oil painting
100 x 160 cm

There is an animated Dr Seuss cartoon called *Horton Hears a Who!*, which tells the story of an elephant. One day, the elephant discovers a speck of dust on a flower. It hears someone speaking and believes that there must be someone living there. Inside this speck of dust there really was a town, called 'Whoville', in which people lived happily.

Everything in the universe continuously reproduces. Big things contain smaller things, while smaller things contain infinite possibilities. Existence implies emptiness while emptiness is equivalent to everything. *I Don't Know* can be applied to our mental space, and to the universe itself. Work with love, and with imagination.

Biography

Zhu Xiaocong was born in 1982. She studied in the Fine Arts Department at Qufo Normal University (Bachelor's Degree 2005), and the Fine Arts Department at Suzhou University (Master's 2008). Group exhibitions are *'Daughter' 'Re-creation' Contemporary Arts Exhibition* Yucun Art Gallery Suzhou 2012, *Pregnant / Vast Contemporary Arts Exhibition* Yucun Art Gallery Suzhou 2013.

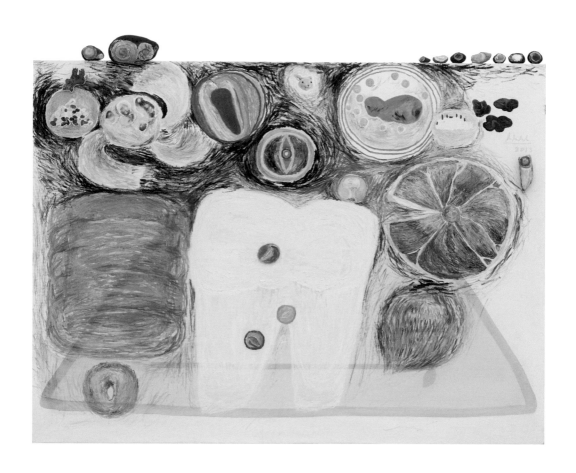

Zhu Xiaocong

约翰·莫尔绘画奖（中国）

John Moores Painting Prize (China)

**JOHN MOORES
LIVERPOOL
EXHIBITION TRUST**

Shanghai University,
Fine Arts Academy

would like to thank our sponsor

our academic partner

and the support of

John Moores Painting Prize previous first prizewinners

1957
Jack Smith
Creation and Crucifixion

© Jack Smith courtesy Flowers Gallery

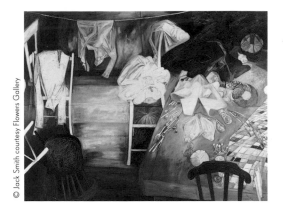

1959
Patrick Heron
Black Painting - Red, Brown, Olive :
July 1959
*Private Collection, courtesy of
Offer Waterman & Co*

© Estate of Patrick Heron. All rights reserved, DACS 2014

1961
Henry Mundy
Cluster
Bristol Museum & Art Gallery

© Bristol Museum & Art Gallery

1963
Roger Hilton
March 1963

**Unless otherwise stated, these artworks are now part of the
Walker Art Gallery's collection.**

1965
Michael Tyzack
Alesso B

1969 (joint winner)
Mary Martin
Cross

© Estate of the Artist

1967
David Hockney
Peter Getting Out of Nick's Pool

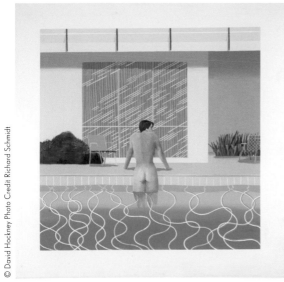

© David Hockney Photo Credit Richard Schmidt

1969 (joint winner)
Richard Hamilton
Toaster
Private collection

© R. Hamilton

1974
Myles Murphy
Figure Against a Yellow Foreground
Tate

© Myles Murphy

1972
Euan Uglow
Nude, 12 regular vertical positions
from the eye
*University of Liverpool Victoria Gallery
and Museum Collection*

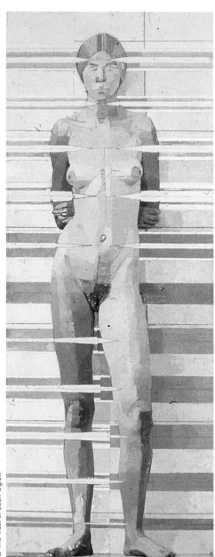

© The Trust of Euan Uglow

1976
John Walker
"Juggernaut with Plume - for P. Neruda"
Collection of the artist

1978
Noel Forster
A Painting in Six Stages with a Blue Triangle

By permission of Noel Forster's family @ www.noelforster.co.uk

© John Walker

1980
Mick Moon
Box Room

© Mick Moon

167

© Estate of John Hoyland. All rights reserved. DACS 2014

© Tim Head

1985
Bruce McLean
Oriental Garden, Kyoto

© Bruce McLean

1989
Lisa Milroy
Handles

© Lisa Milroy

1993
Peter Doig
Blotter

© The Artist

1991
Andrzej Jackowski
Beekeeper's Son

© The Artist

1995
David Leapman
Double Tongued Knowability

© David Leapman

1997
Dan Hays
Harmony in Green

© Dan Hays

2002
Peter Davies
Super Star Fucker

© Peter Davies

1999
Michael Raedecker
Mirage

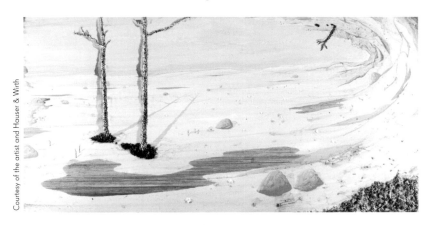

Courtesy of the artist and Hauser & Wirth

2004
Alexis Harding
Slump/Fear (orange/black)

Courtesy of the artist and Mummery & Schnelle Gallery

2006
Martin Greenland
Before Vermeer's Clouds

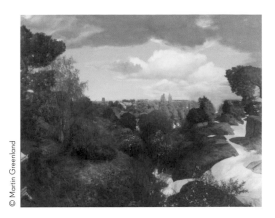

© Martin Greenland

2008
Peter McDonald
Fontana

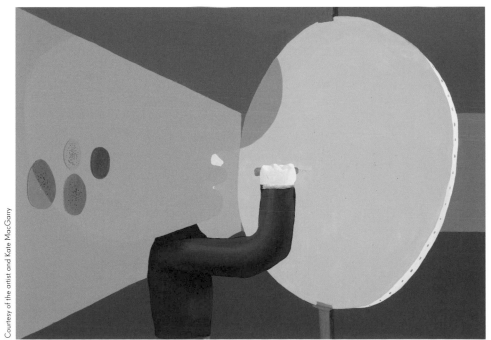

Courtesy of the artist and Kate MacGarry

Keith Coventry

Spectrum Jesus

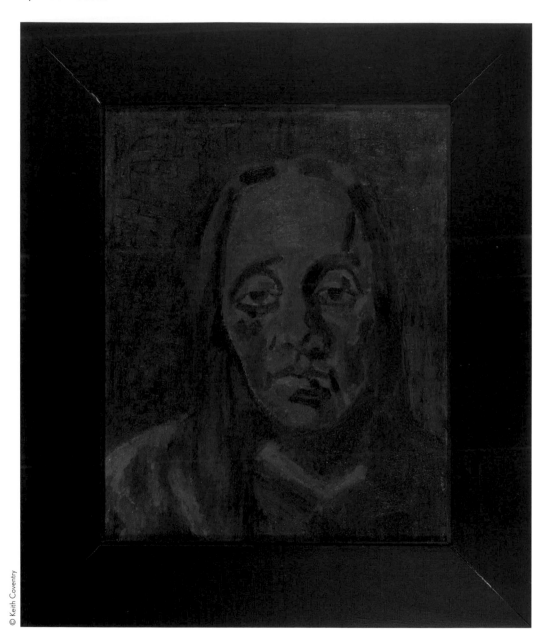

© Keith Coventry

2012
Sarah Pickstone
Stevie Smith and the Willow

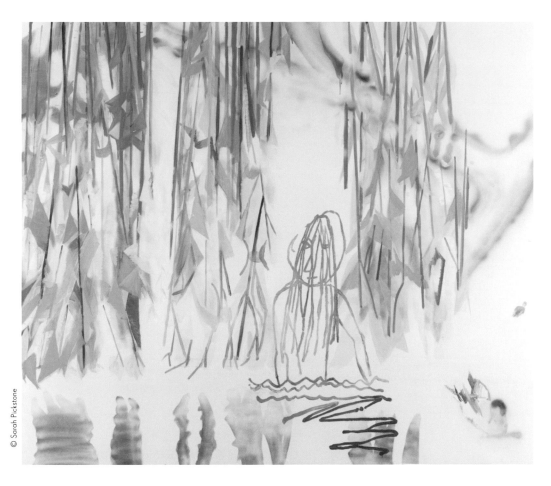

© Sarah Pickstone

This catalogue accompanies the
John Moores Painting Prize 2014
5 July - 30 November 2014
Walker Art Gallery
William Brown Street
Liverpool L3 8EL

www.liverpoolmuseums.org.uk/johnmoores

Photography: Keith Sweeney
Design: Michael Blackburn
Editor: Ann Bukantas
Publications Manager: Karen Miller
John Moores Painting Prize Project Manager: Angela Samata
Modern Masters Project Assistant: Katherine Lloyd

© National Museums Liverpool and the authors. Copyright of the illustrations in
this volume is strictly reserved for the owners by National Museums Liverpool.

Catalogue in publication data available
ISBN: 978-1-902700-51-9

A PARTNERSHIP BETWEEN NATIONAL MUSEUMS LIVERPOOL AND
THE JOHN MOORES LIVERPOOL EXHIBITION TRUST

First Prize Sponsor

DAVID·M·ROBINSON
~ J E W E L L E R Y ~

John Moores Painting Prize 2014 is part of National
Museums Liverpool's Modern Masters exhibition
series part-funded by the European Union - the
European Regional Development Fund (ERDF).